Johanna Basford

LOST OCEAN

An Inky Adventure & Coloring Book

PENGUIN BOOKS

PENGUIN BOOKS

An imprint of Penguin Random House LLC

375 Hudson Street

New York, New York 10014

penguin.com

ISBN 978-0-14-310899-3

Printed in the United States of America

1 3 5 7 9 10 8 6 4 2

Interior designed by Johanna Basford and Amy Hill

This book belongs to

Hidden inside this book are . . .

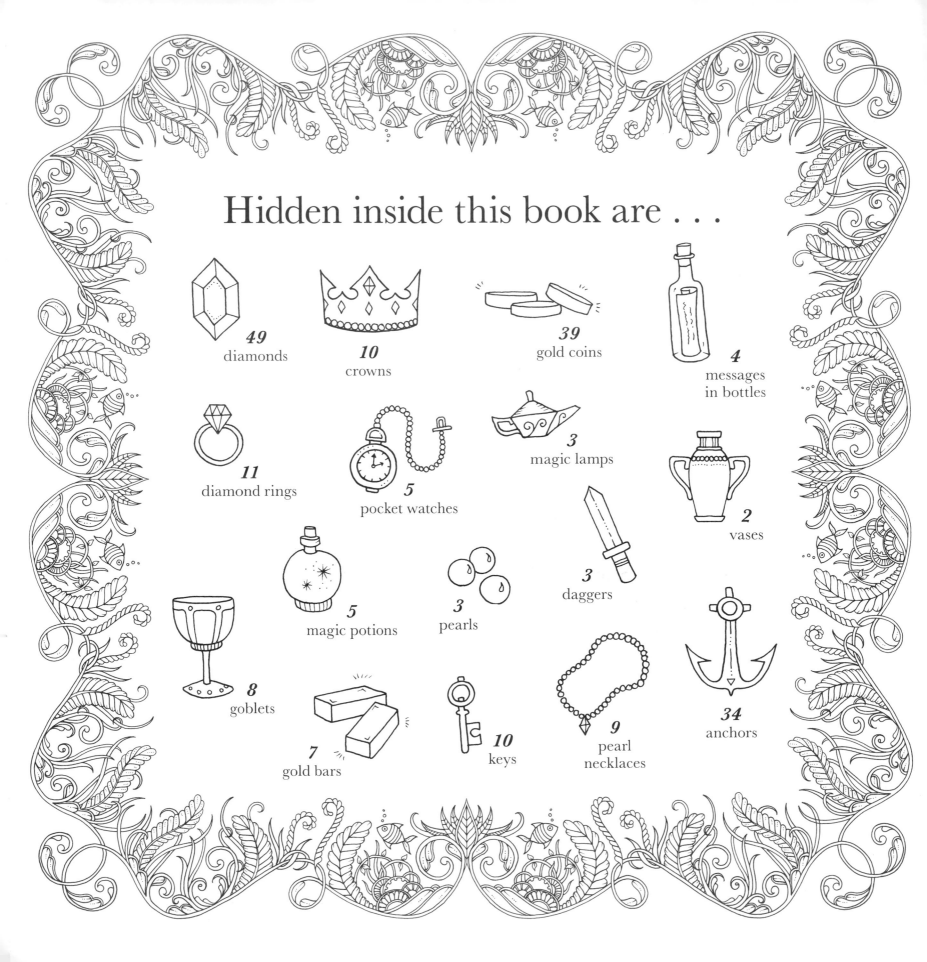

49 diamonds

10 crowns

39 gold coins

4 messages in bottles

11 diamond rings

5 pocket watches

3 magic lamps

2 vases

8 goblets

5 magic potions

3 pearls

3 daggers

7 gold bars

10 keys

9 pearl necklaces

34 anchors

Introduction

Lost Ocean is an inky adventure beneath the waves full of enchanting illustrations for you to color and embellish. From delicate tangles of seaweed to coral reef gardens and sunken shipwrecks, there's lots to discover! Throughout this book you will encounter curious octopuses, magical mermaids, and plenty of exotic fish, all waiting for you to bring them to life with color!

And, of course, it wouldn't be an adventure without some treasure. Scattered throughout the pages are treasures and trinkets from the pirate's chest. Can you find all the hidden objects?

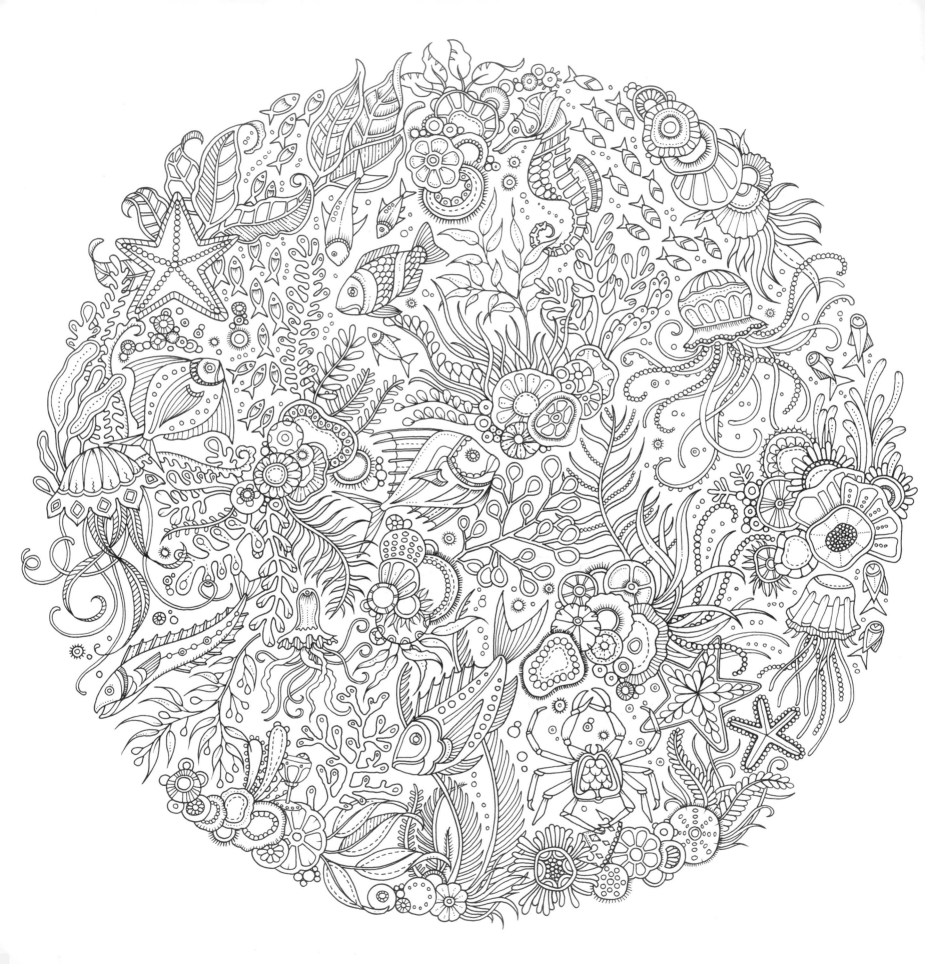

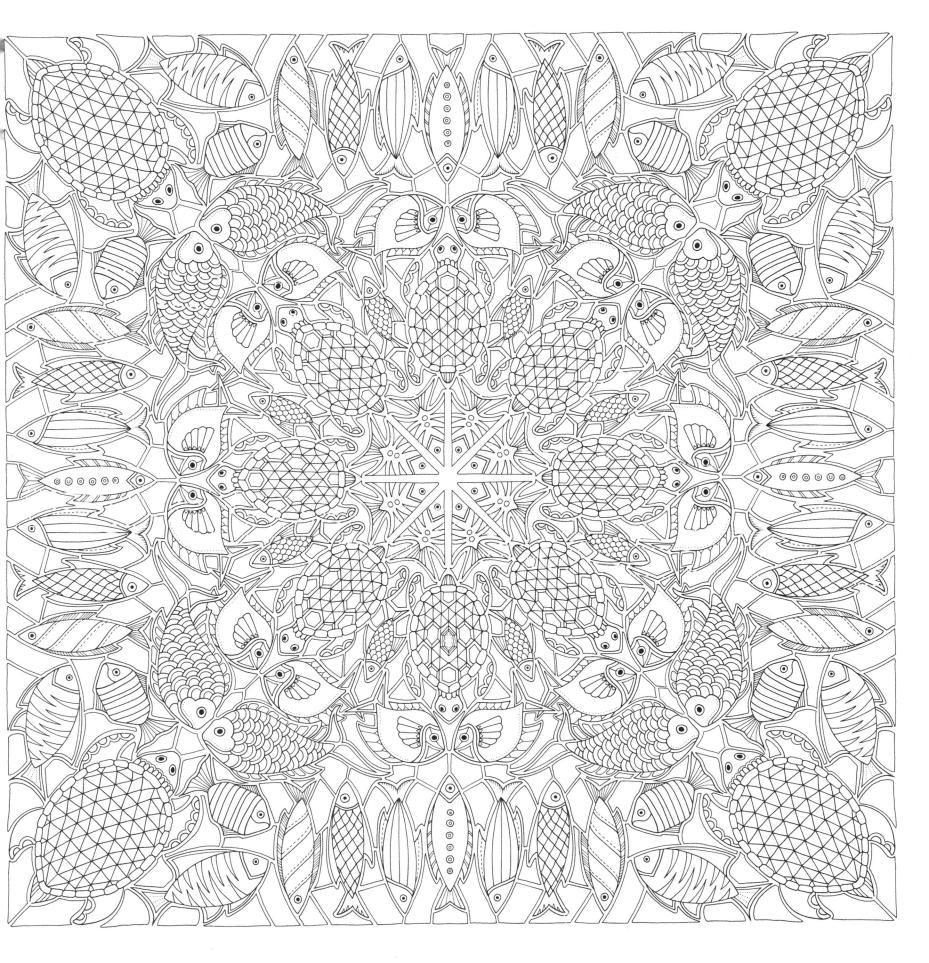

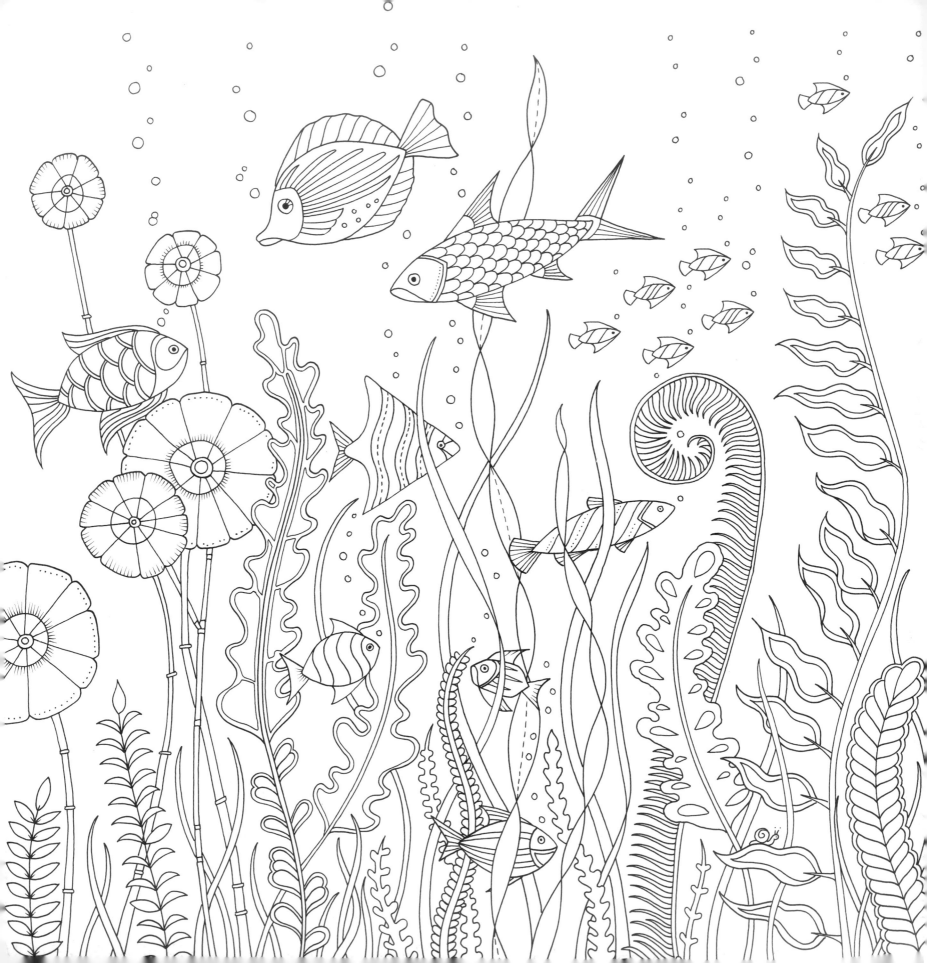

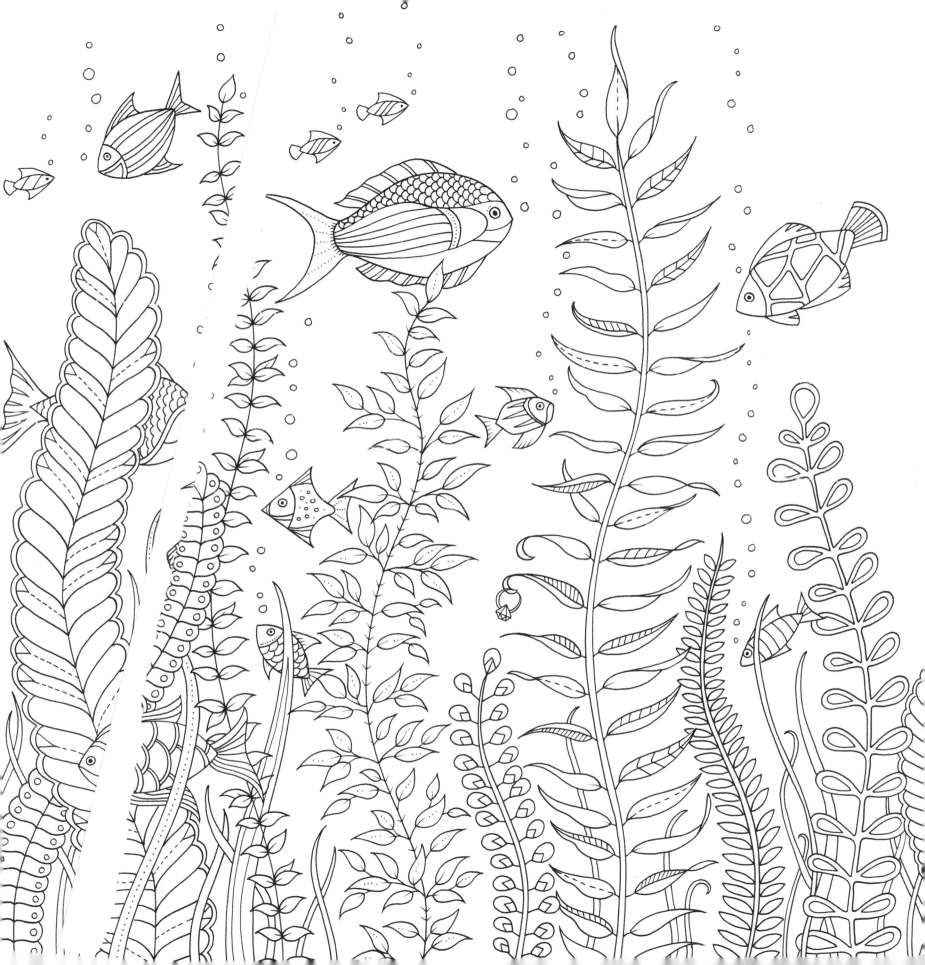

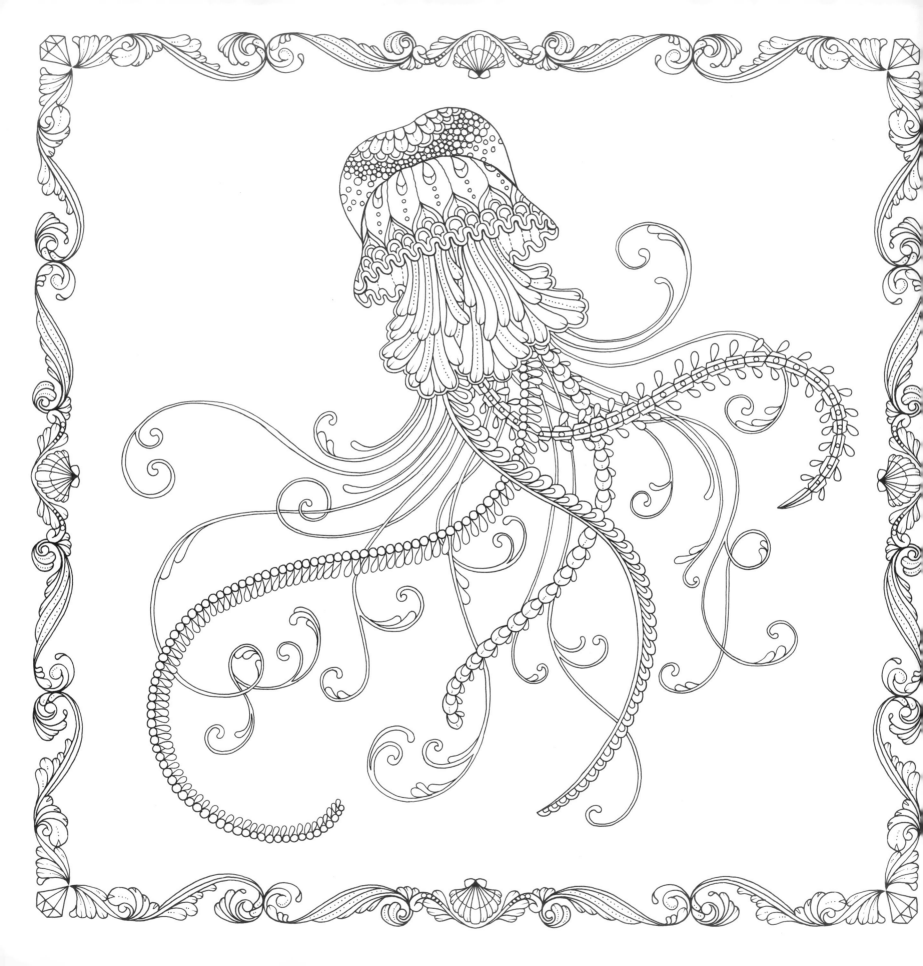

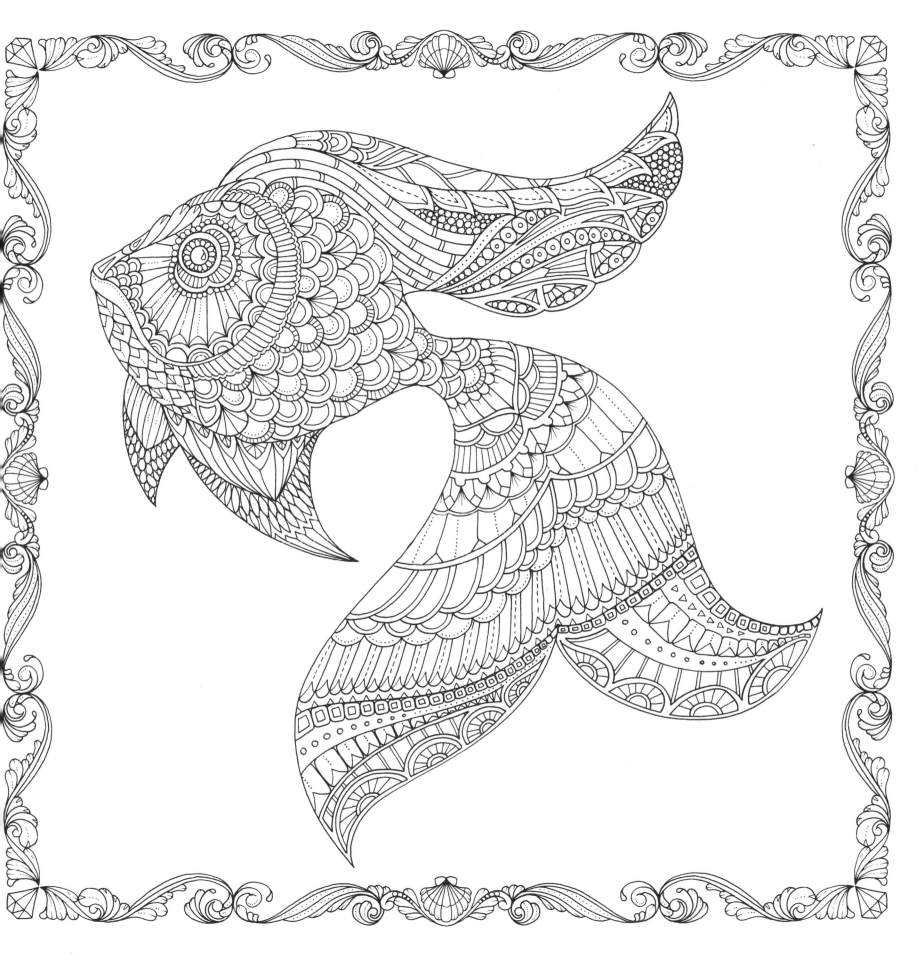

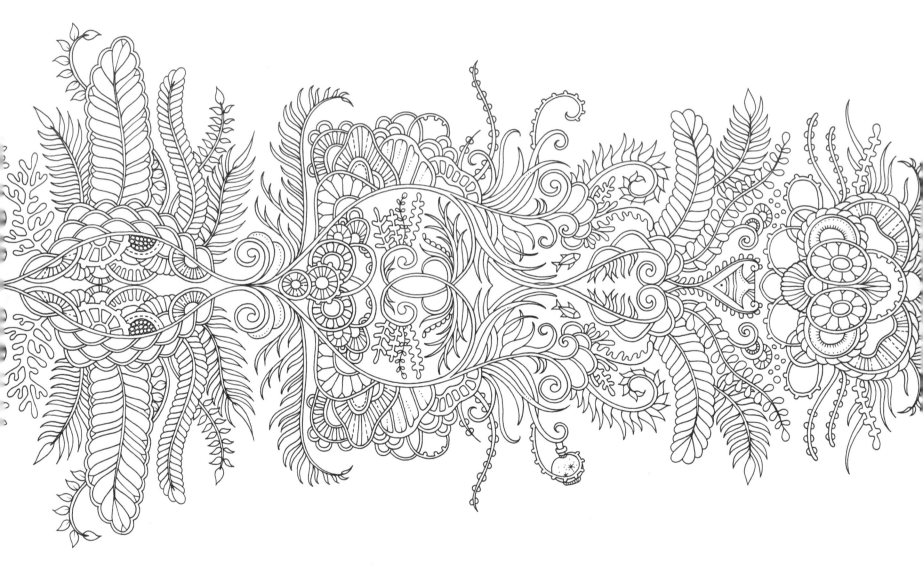

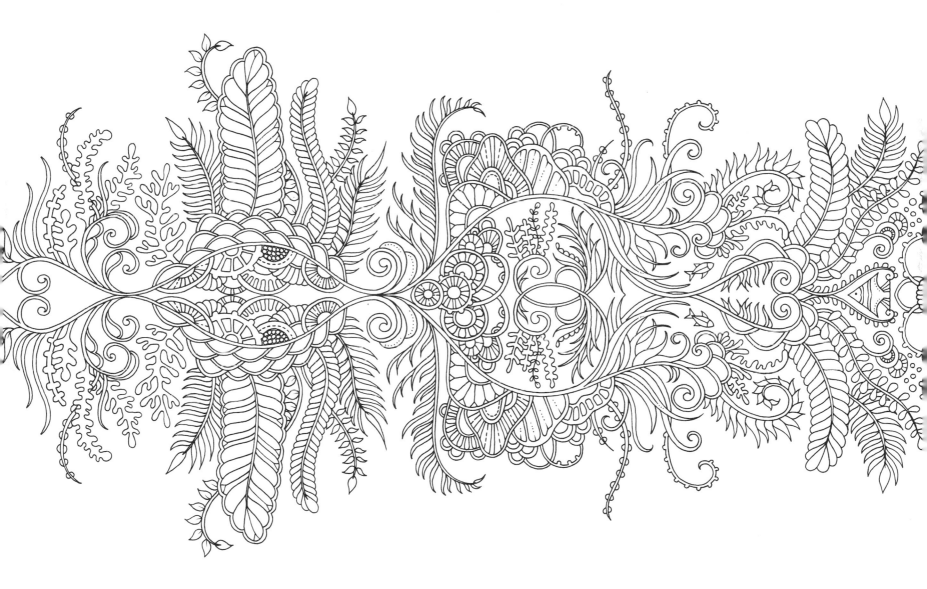

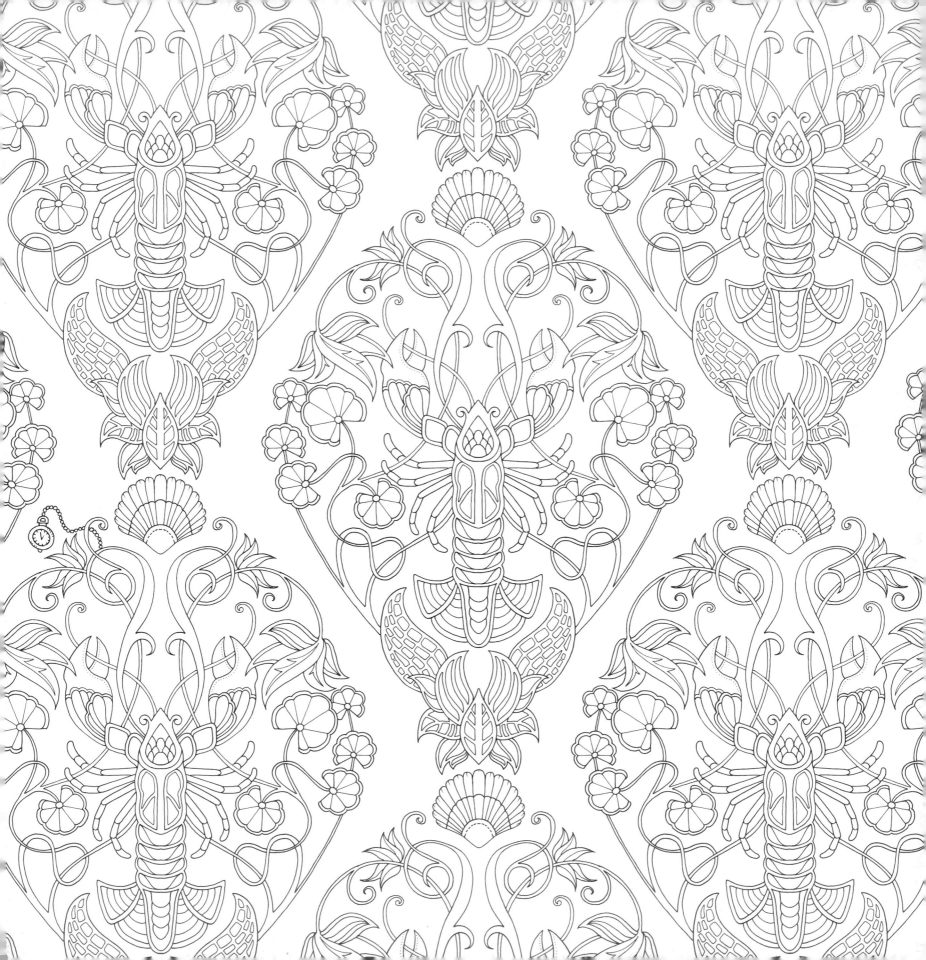

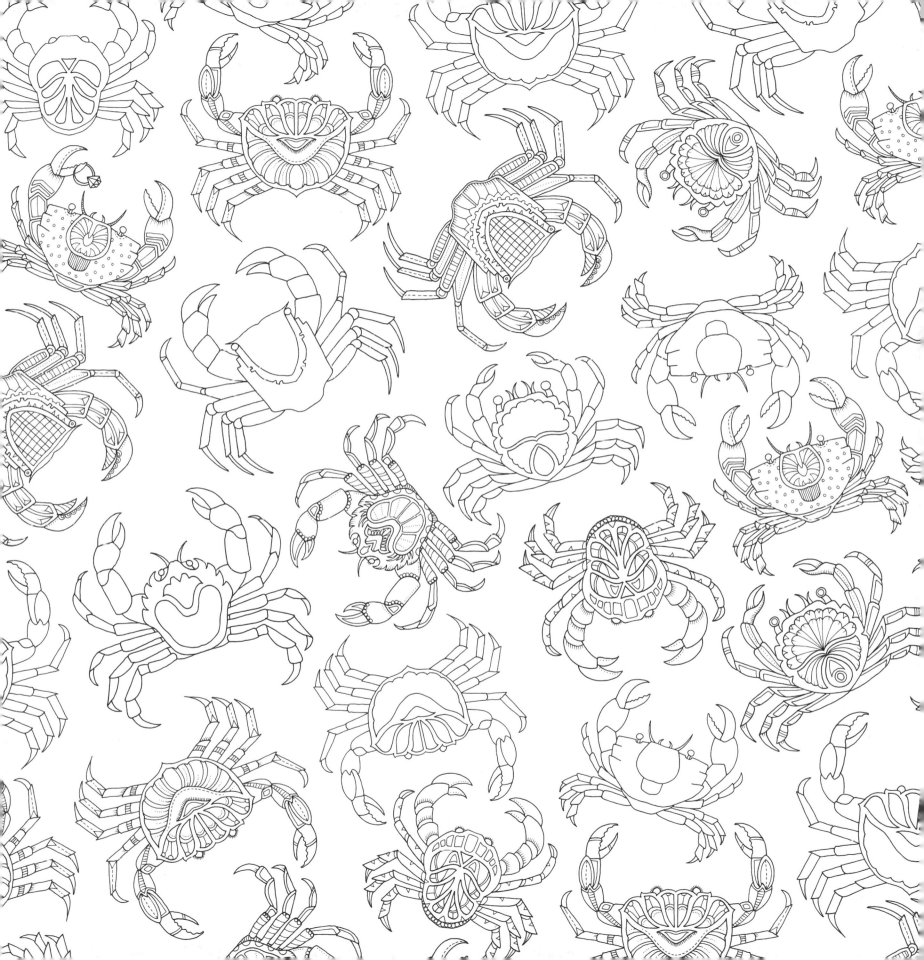

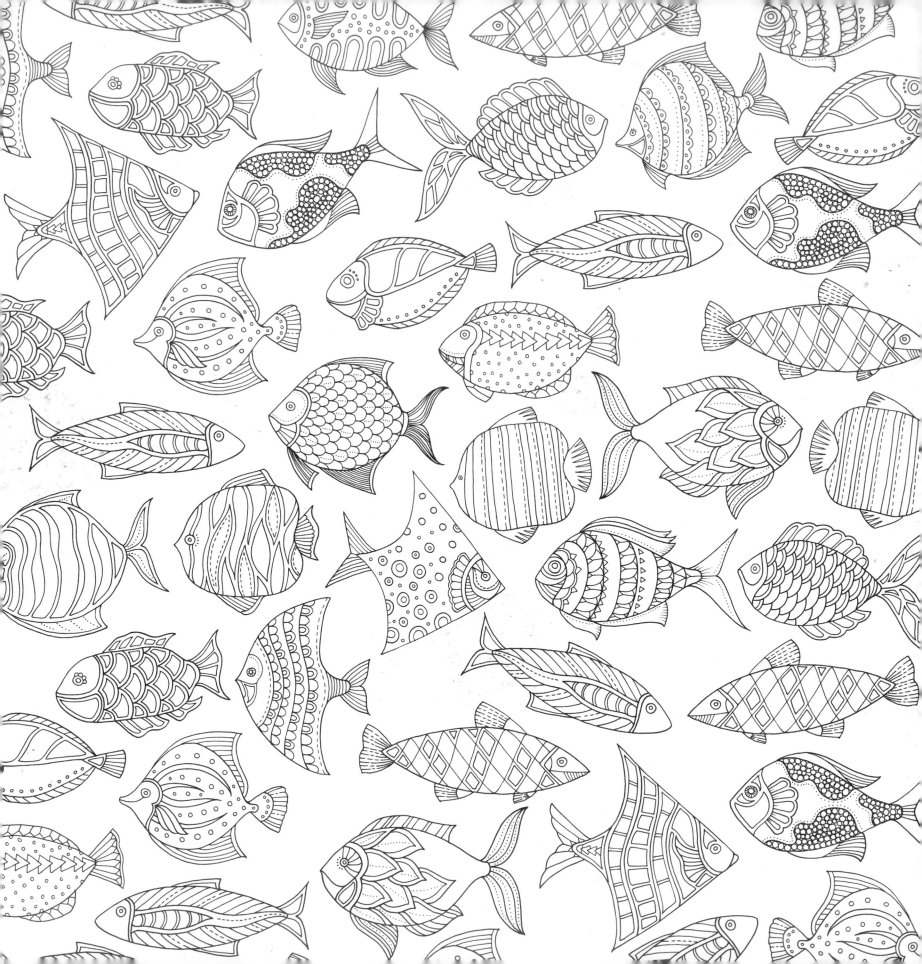

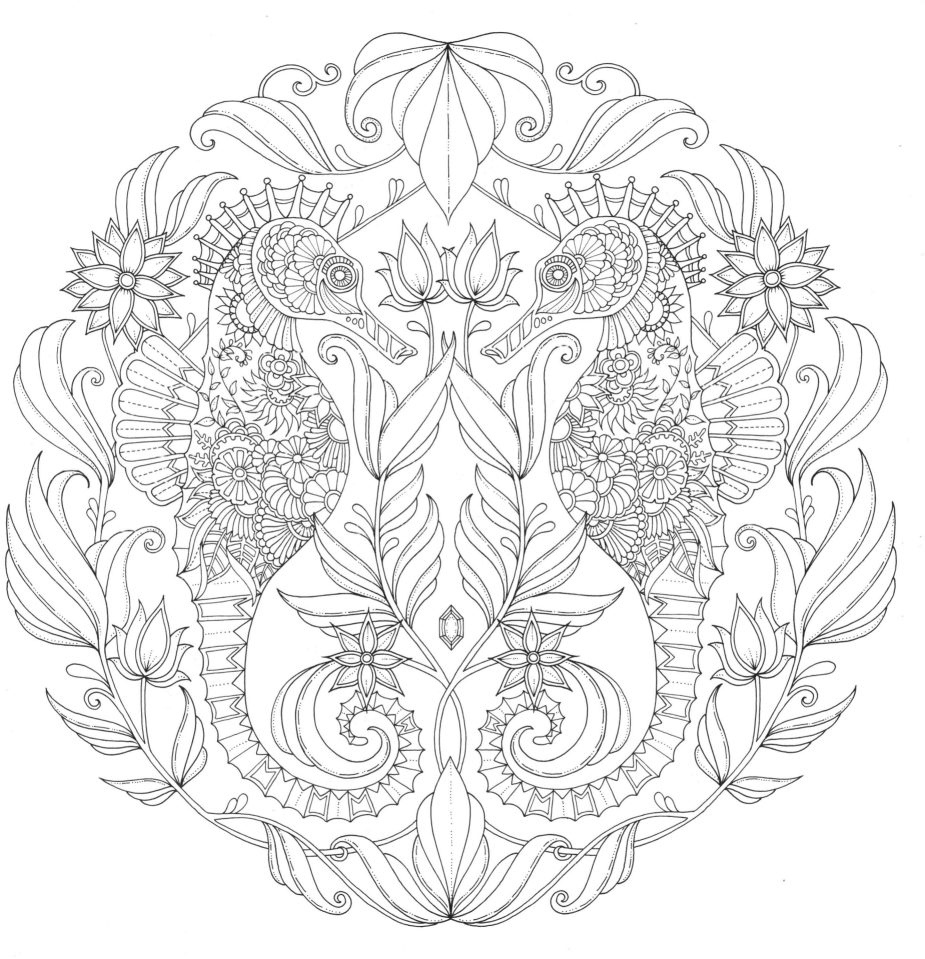

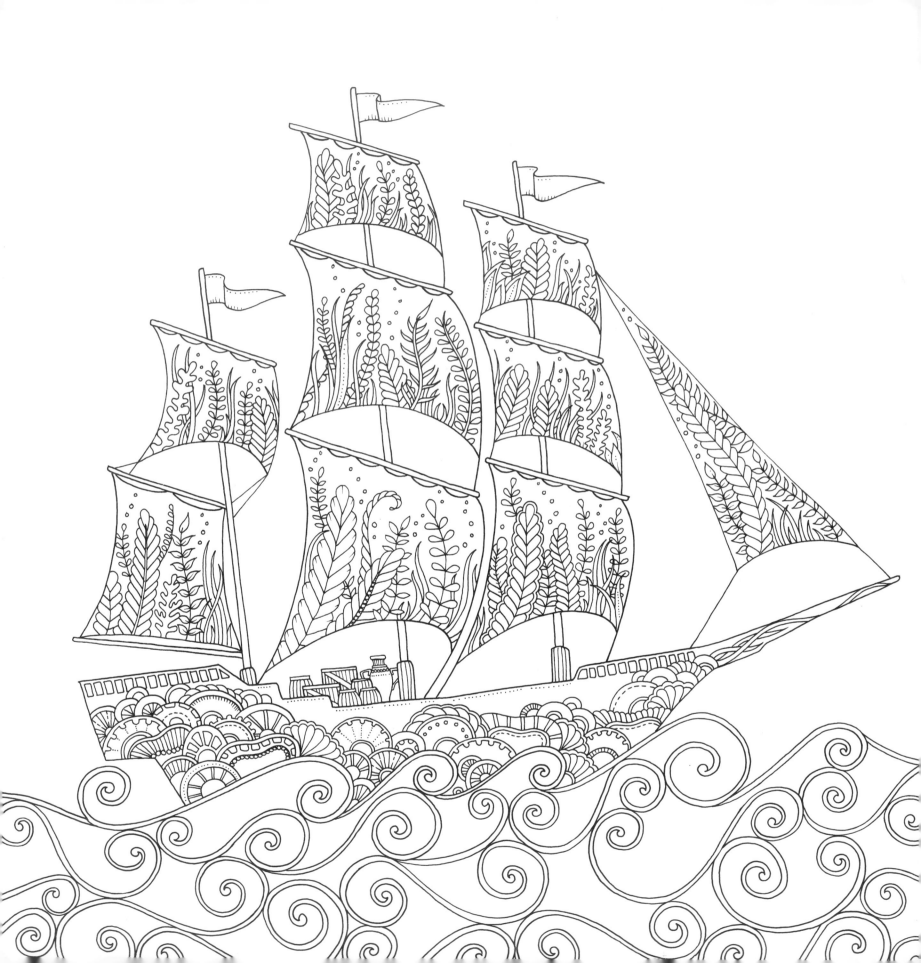

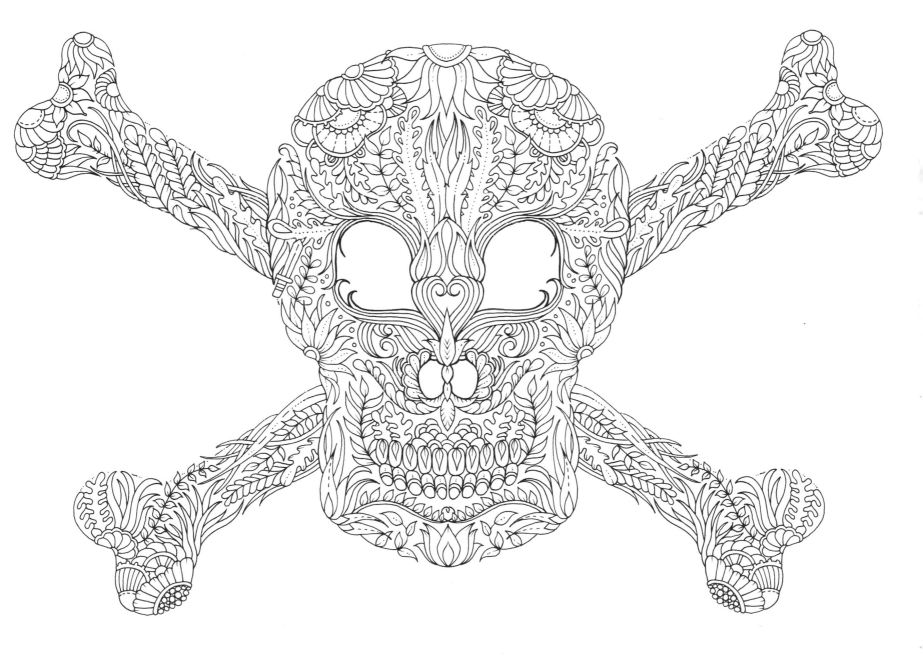

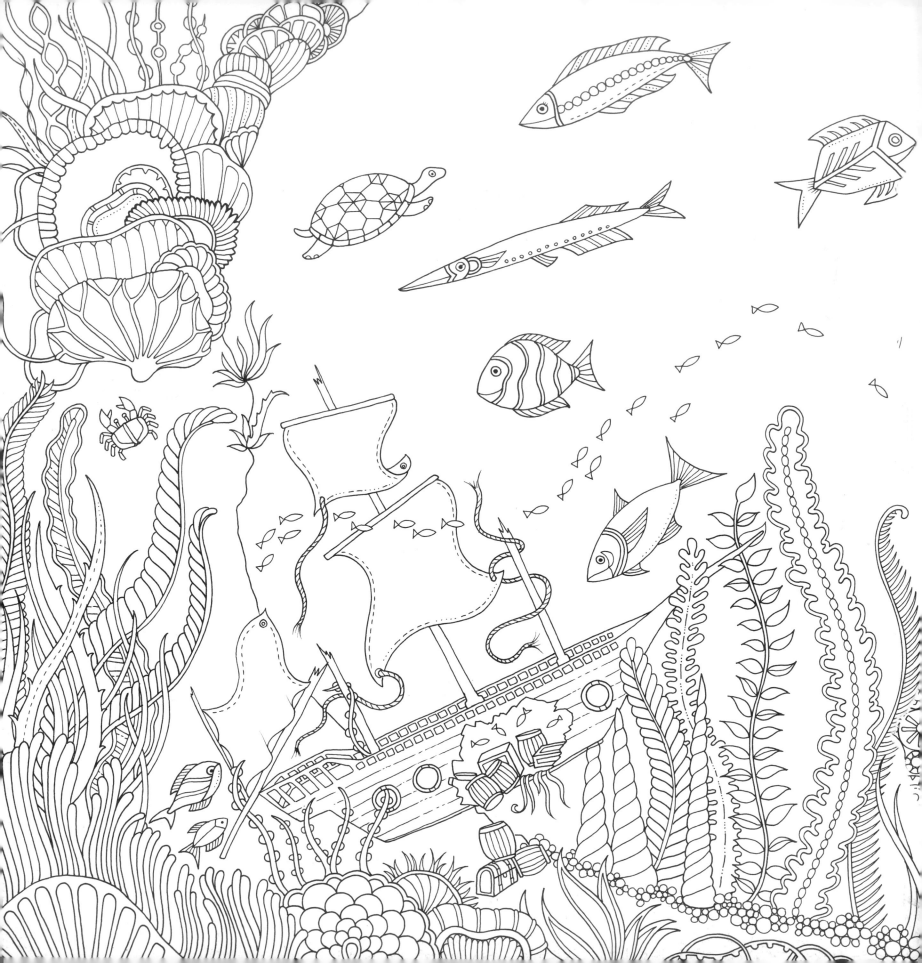

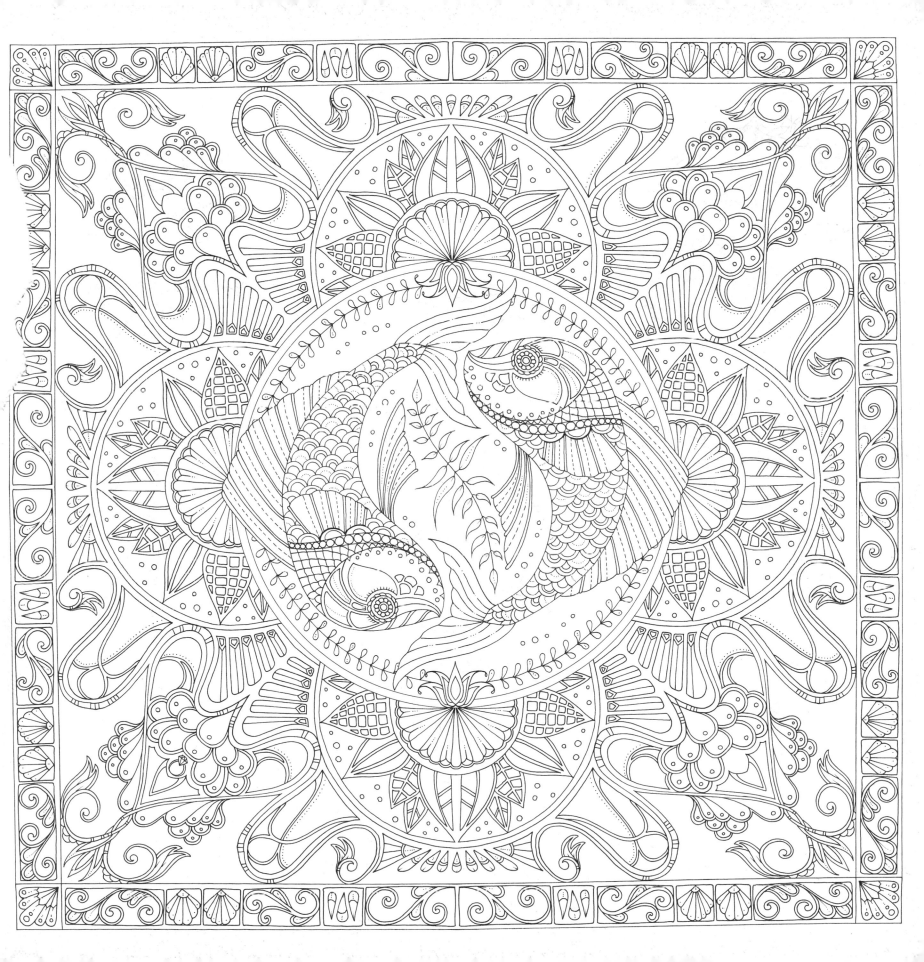

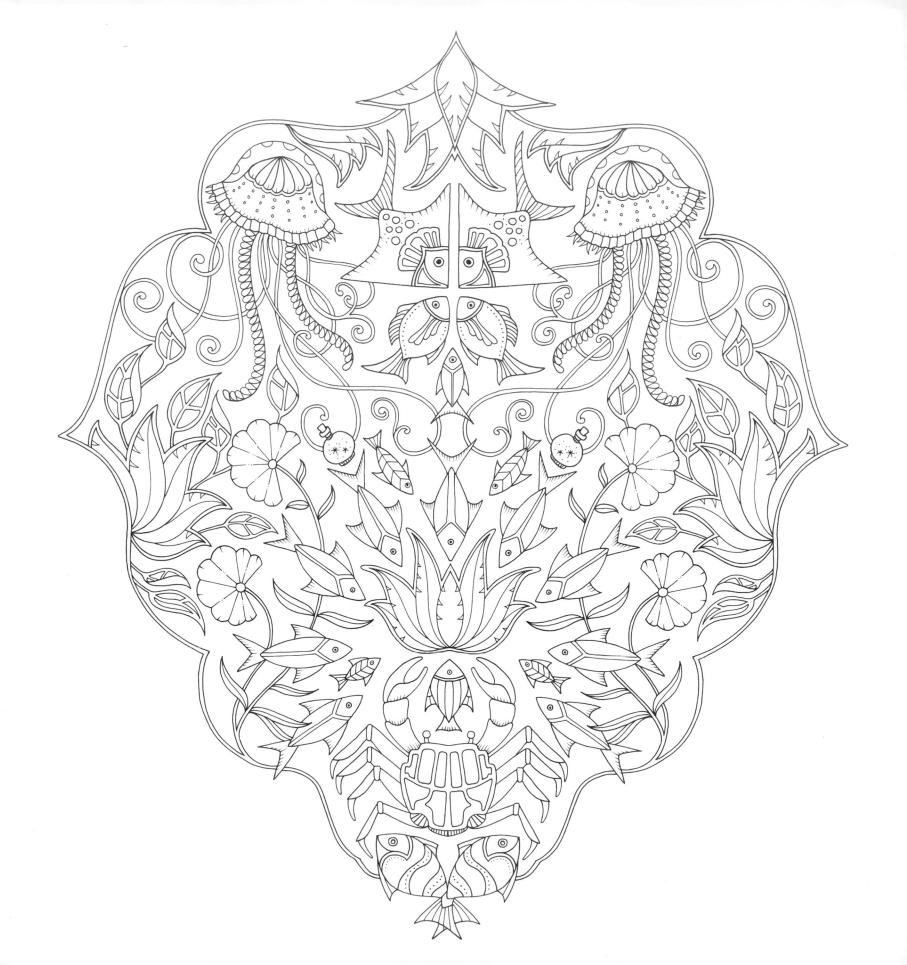

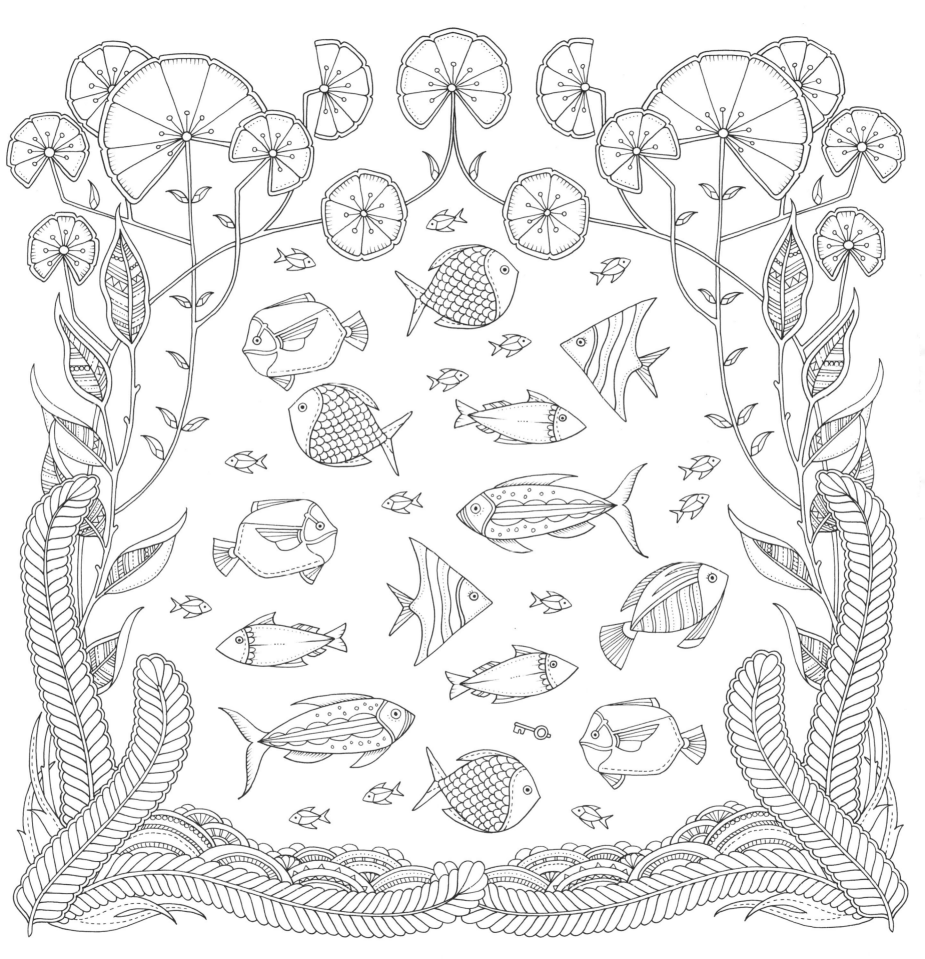

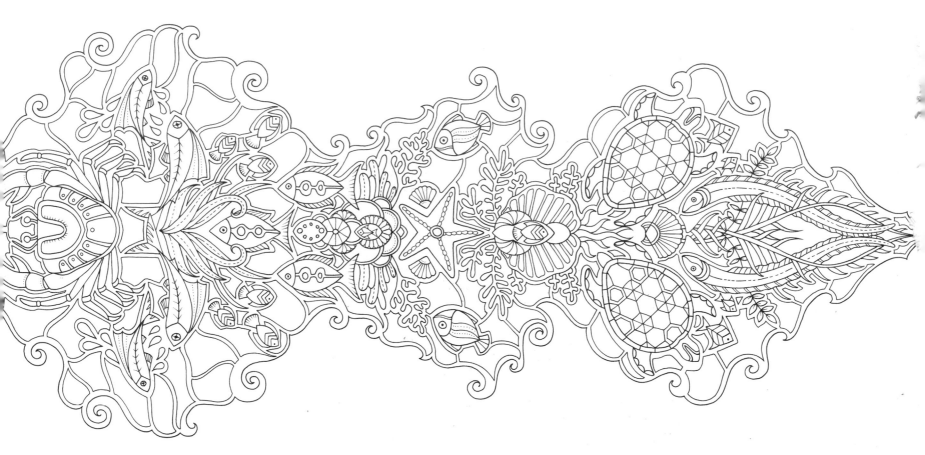

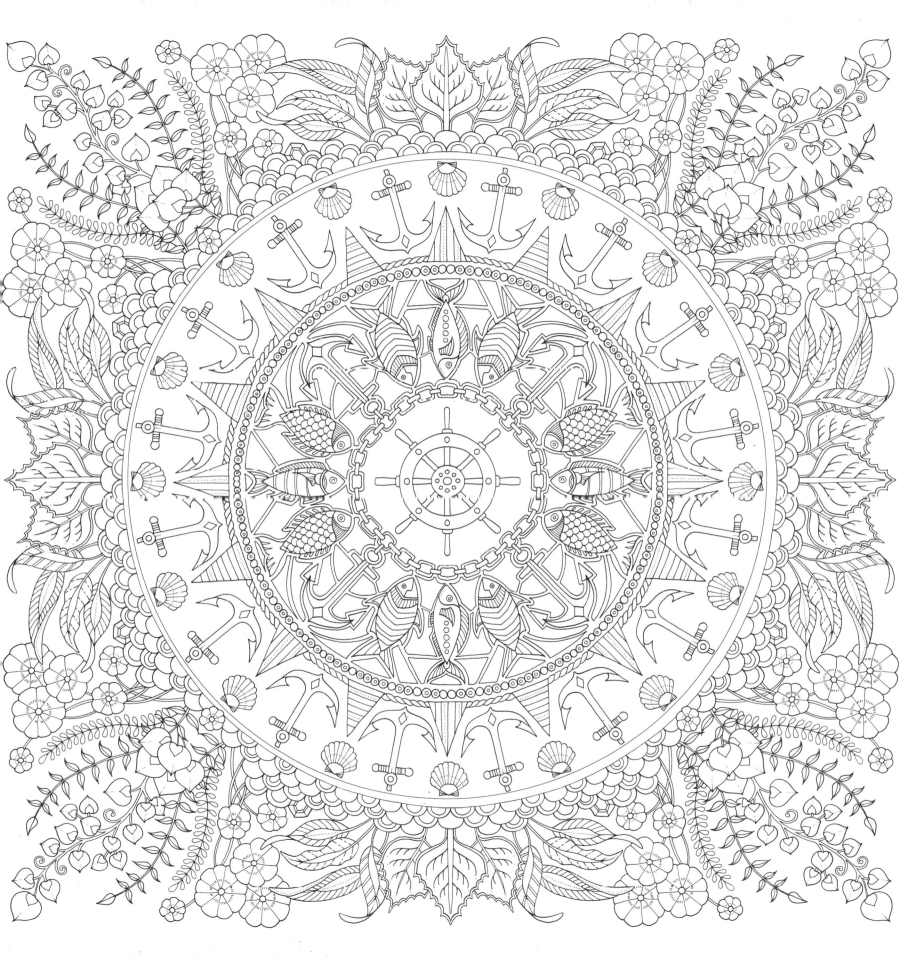

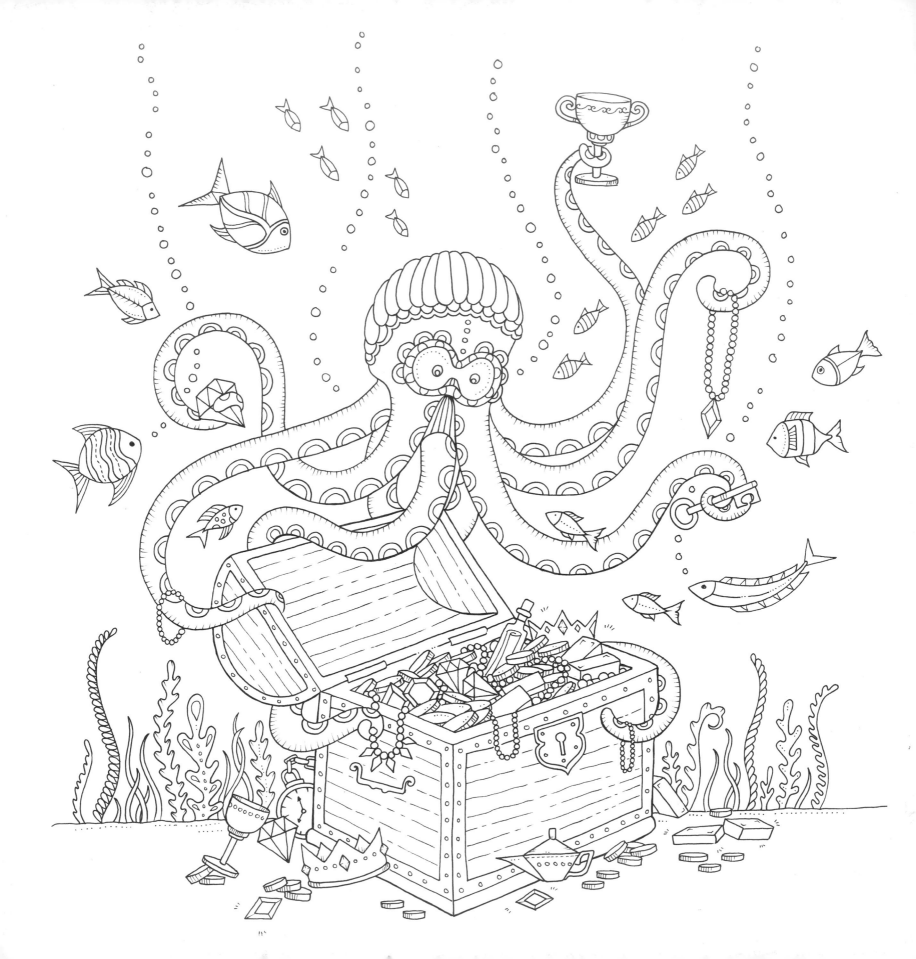

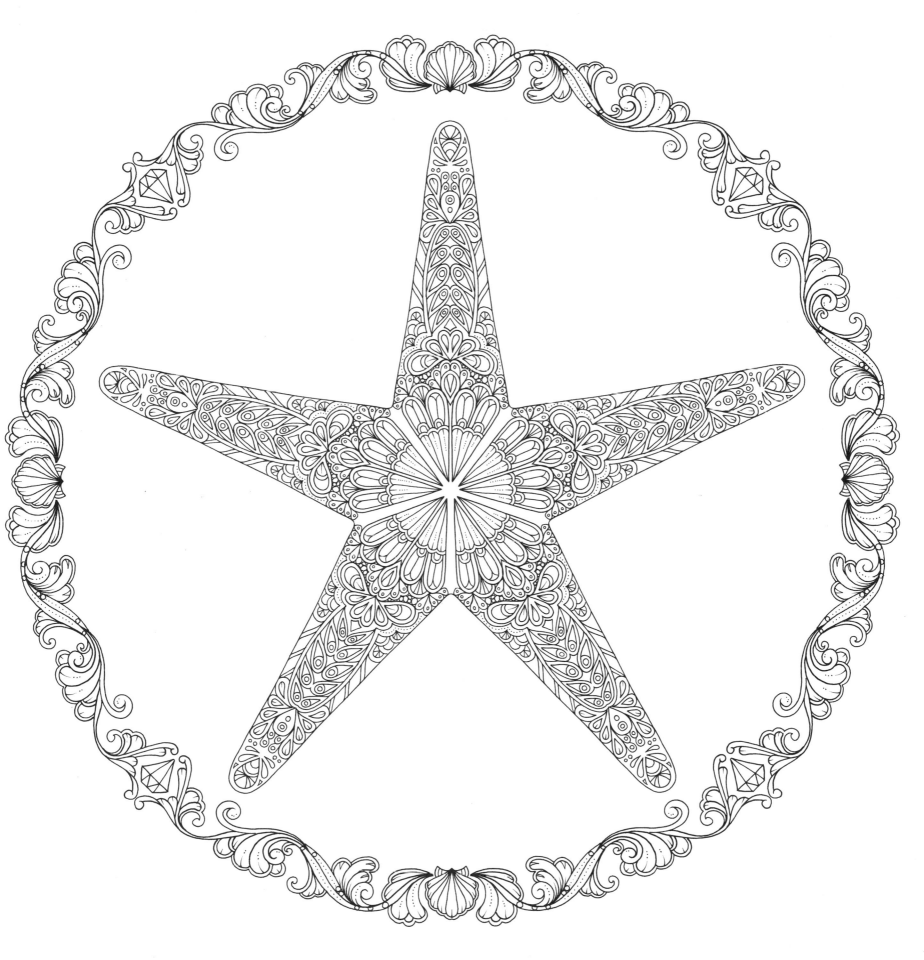

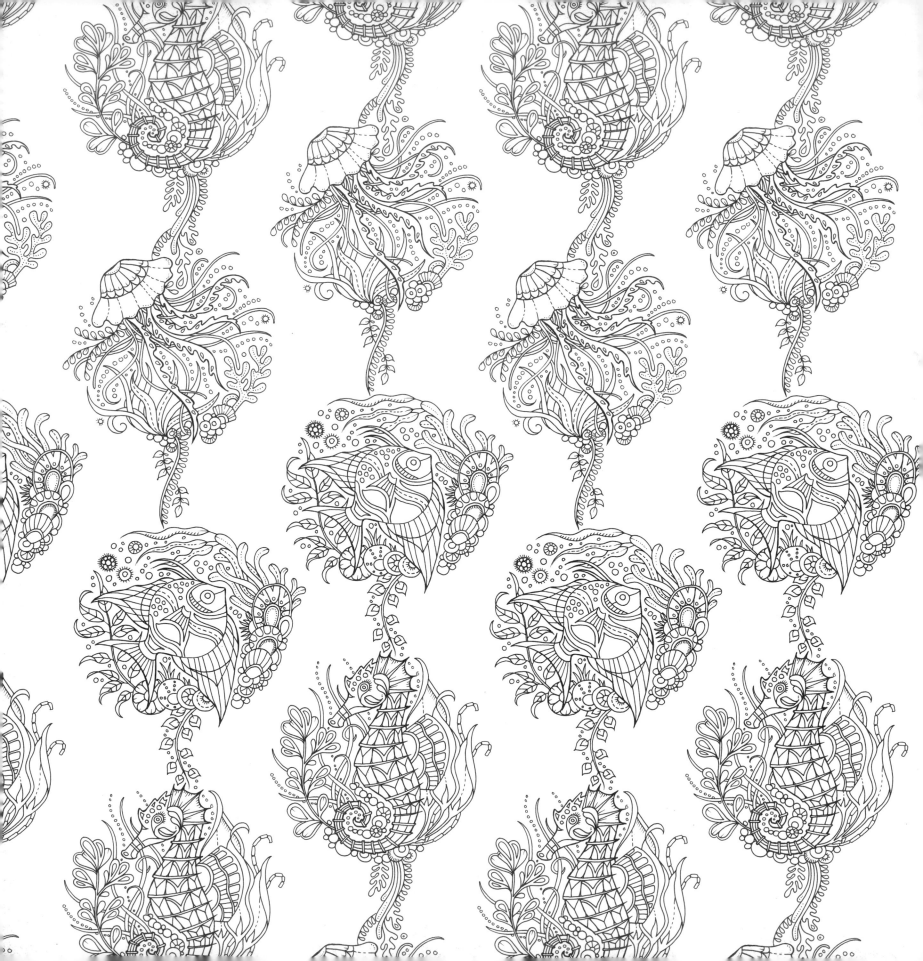

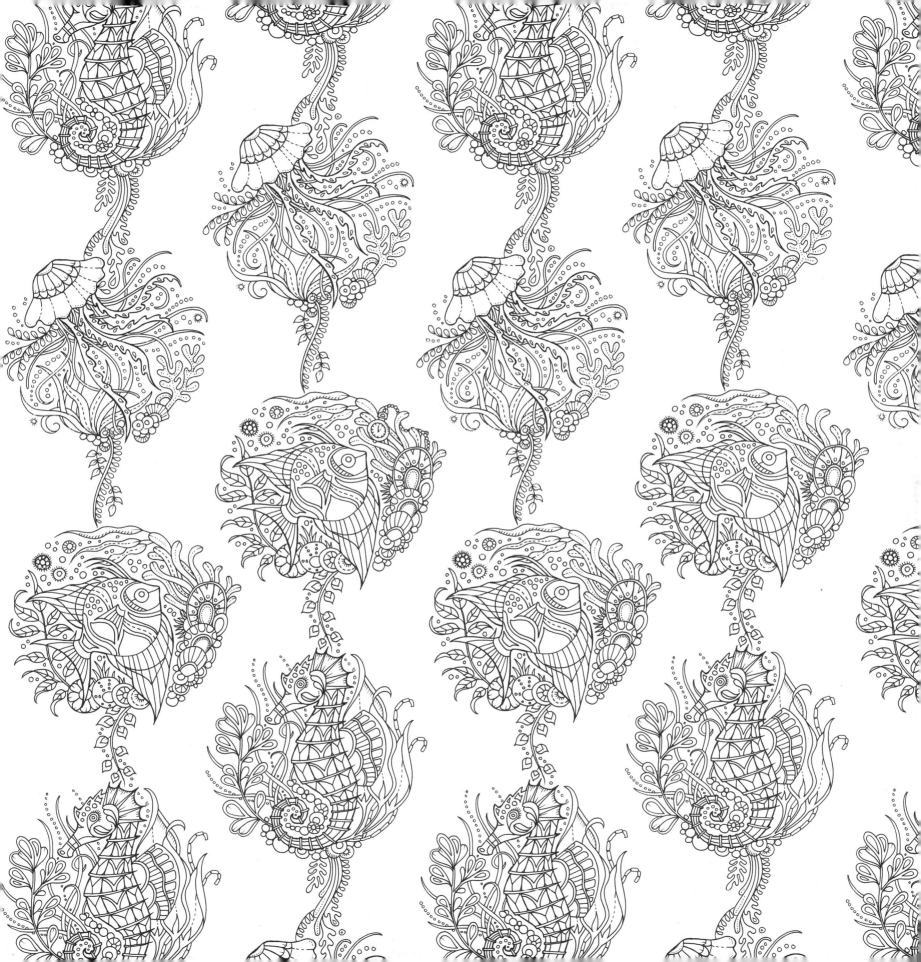

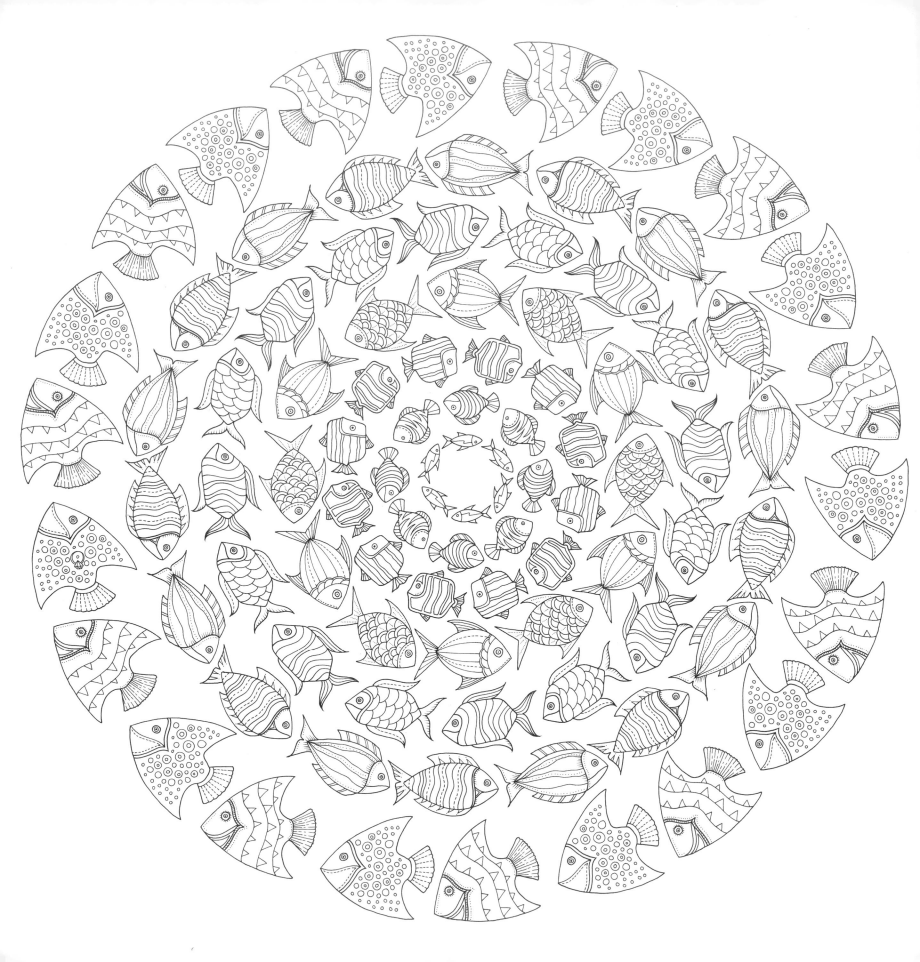

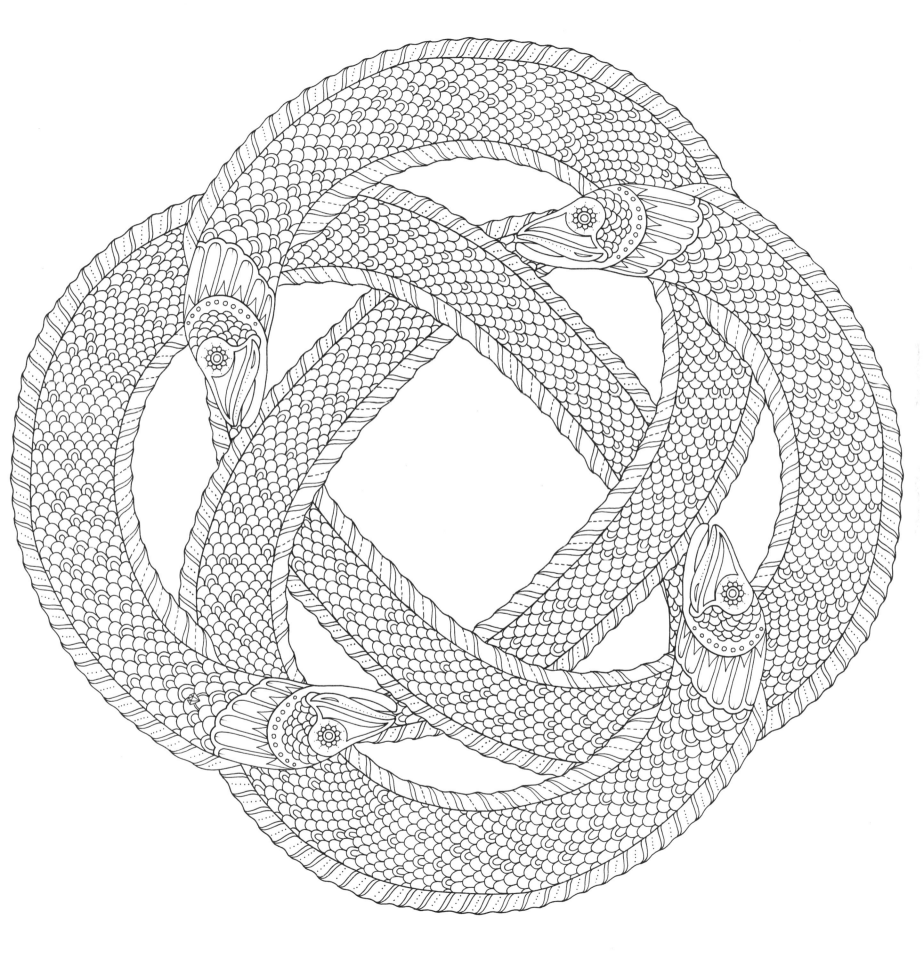

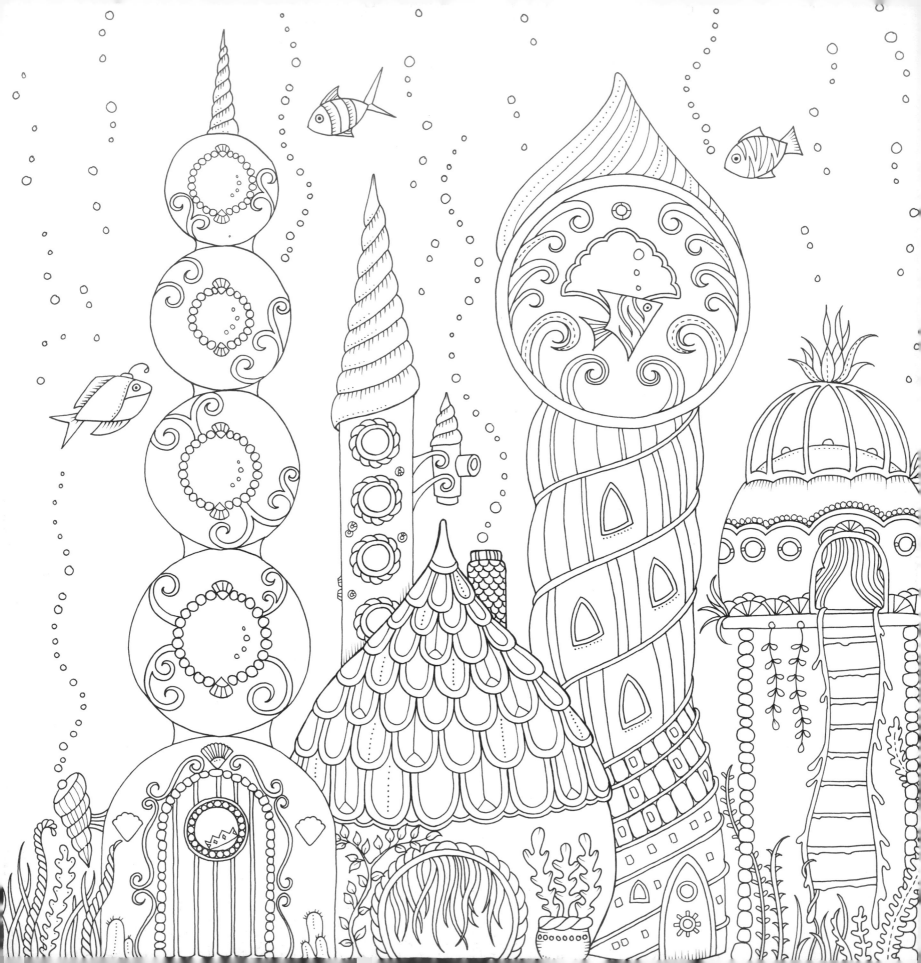

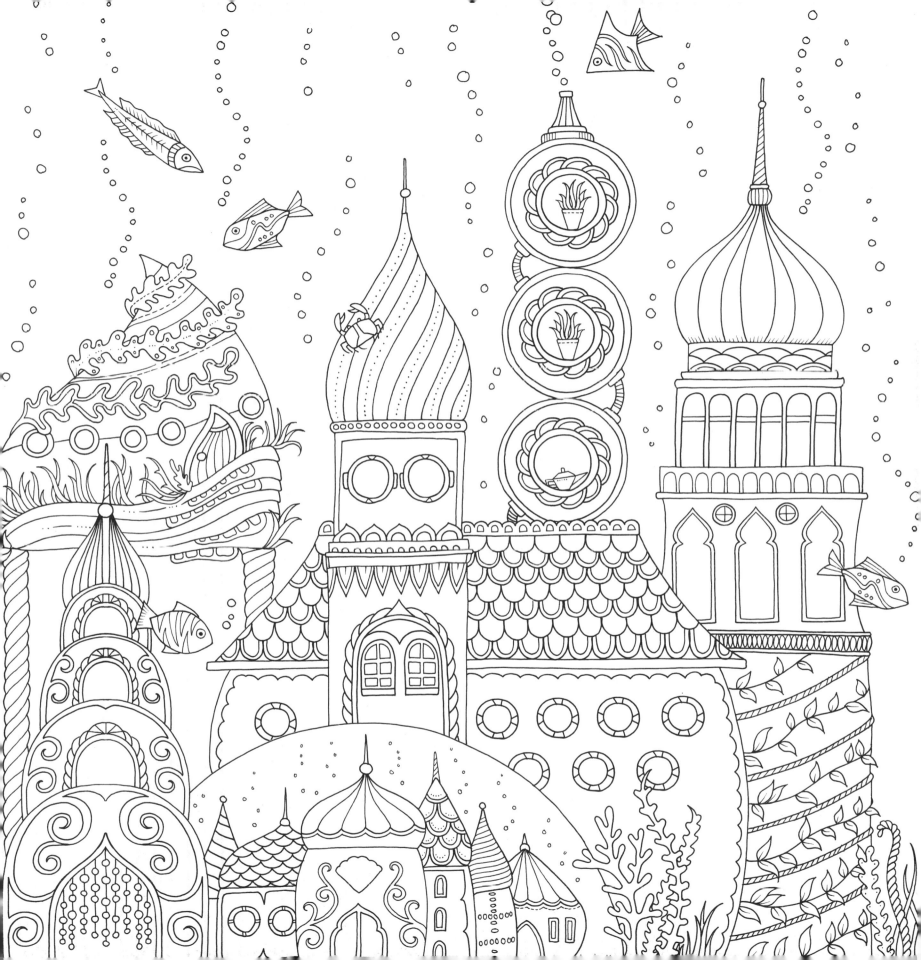

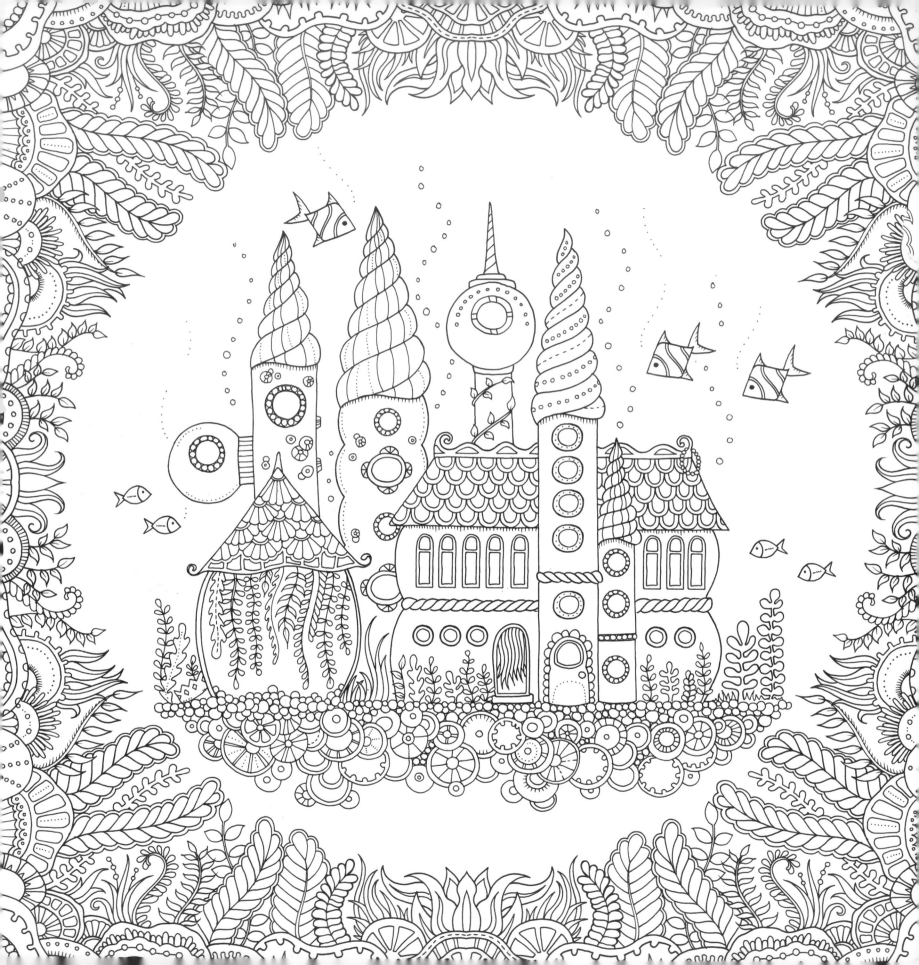

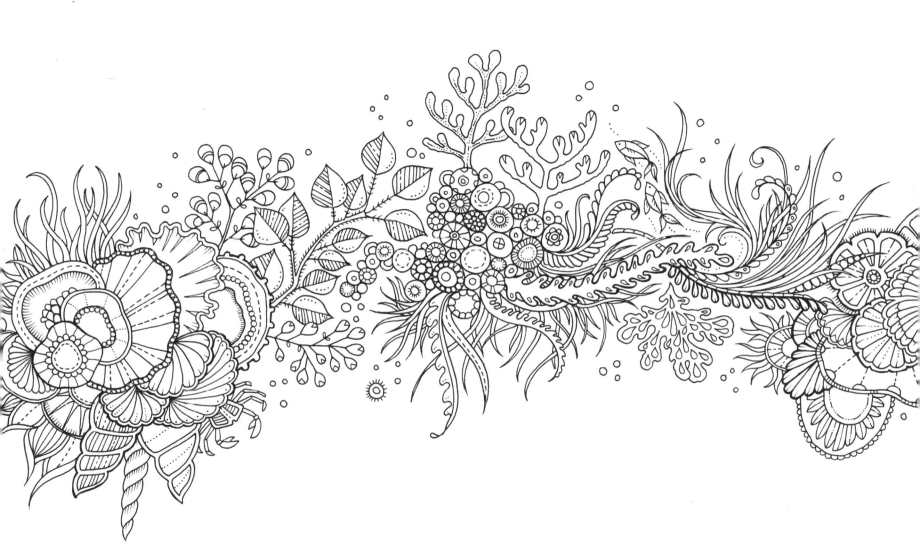

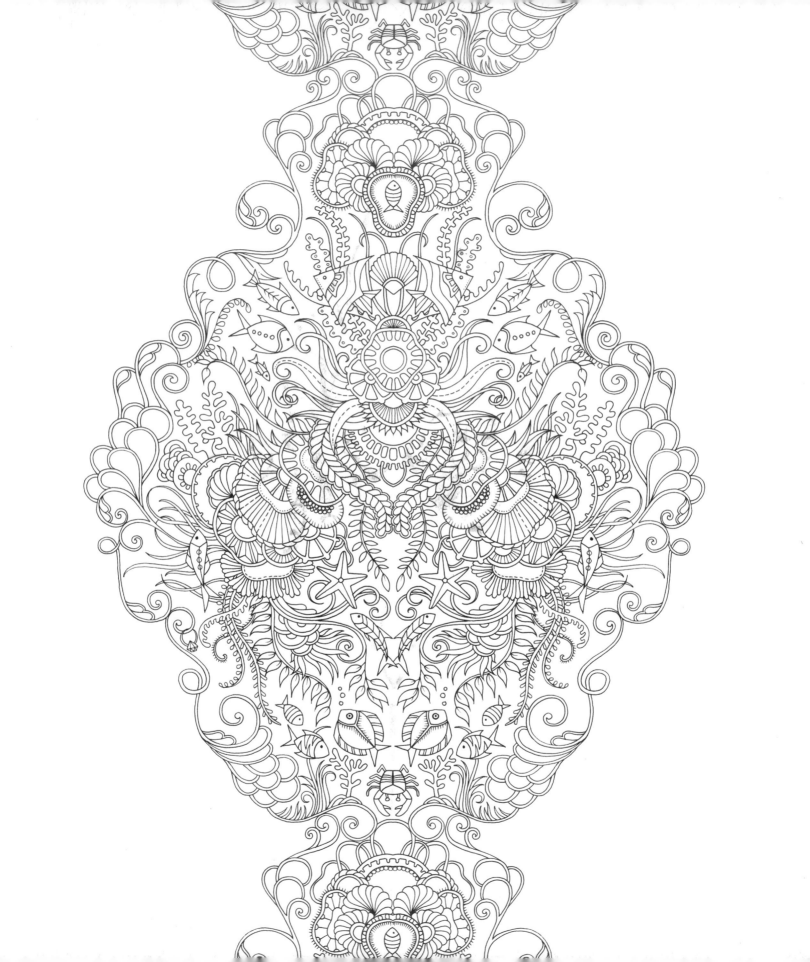

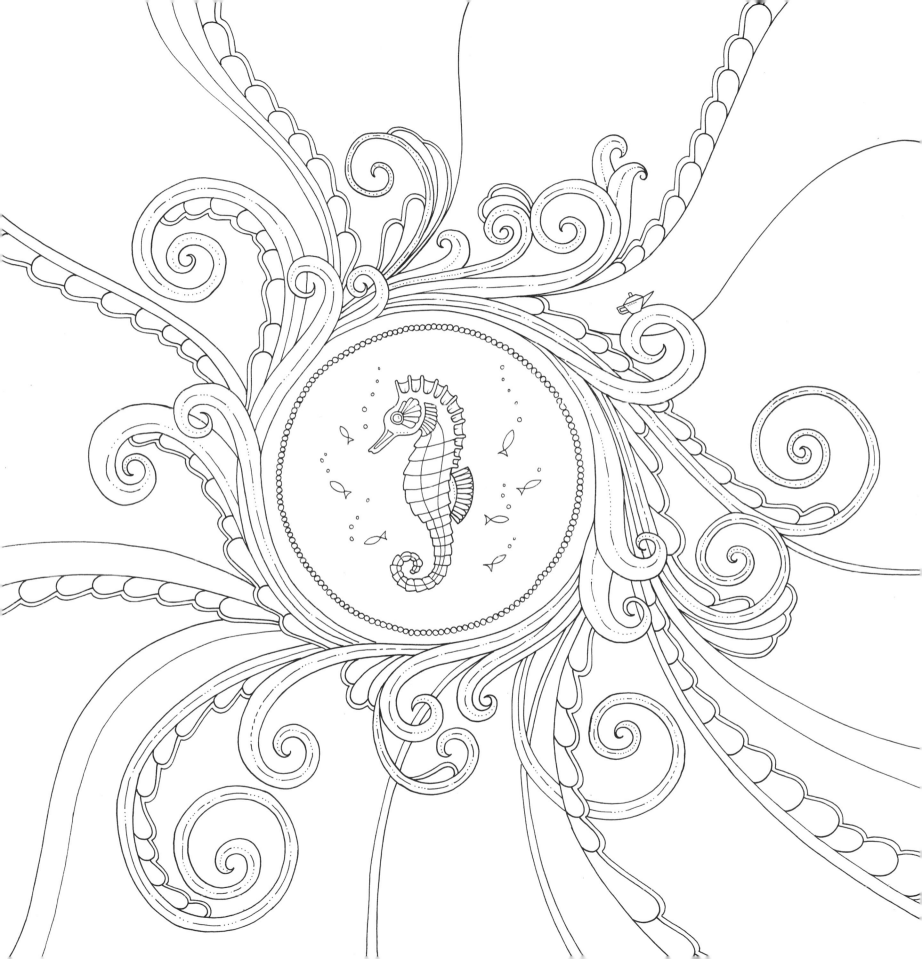

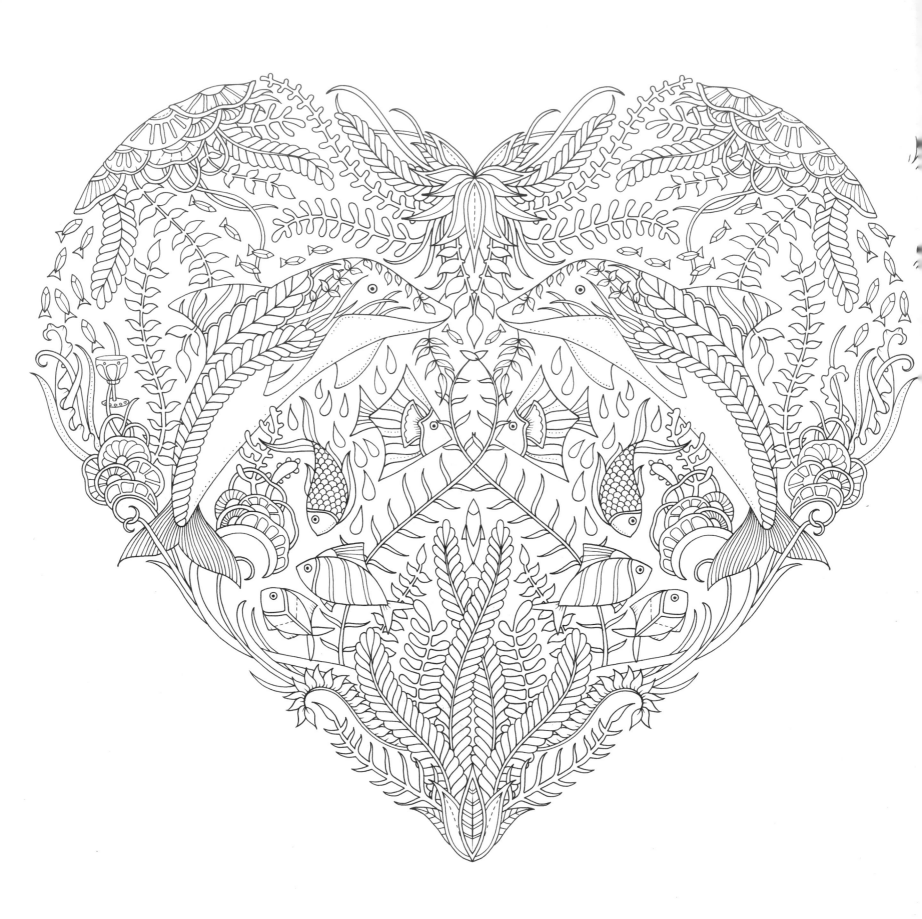

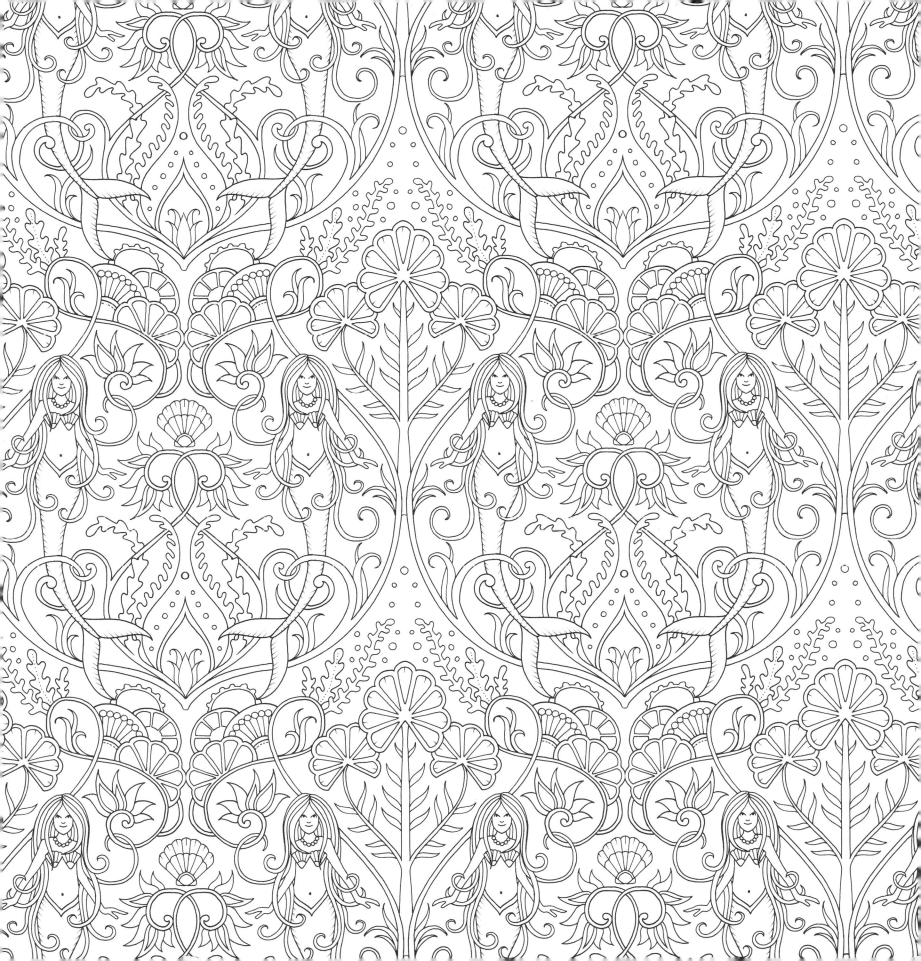

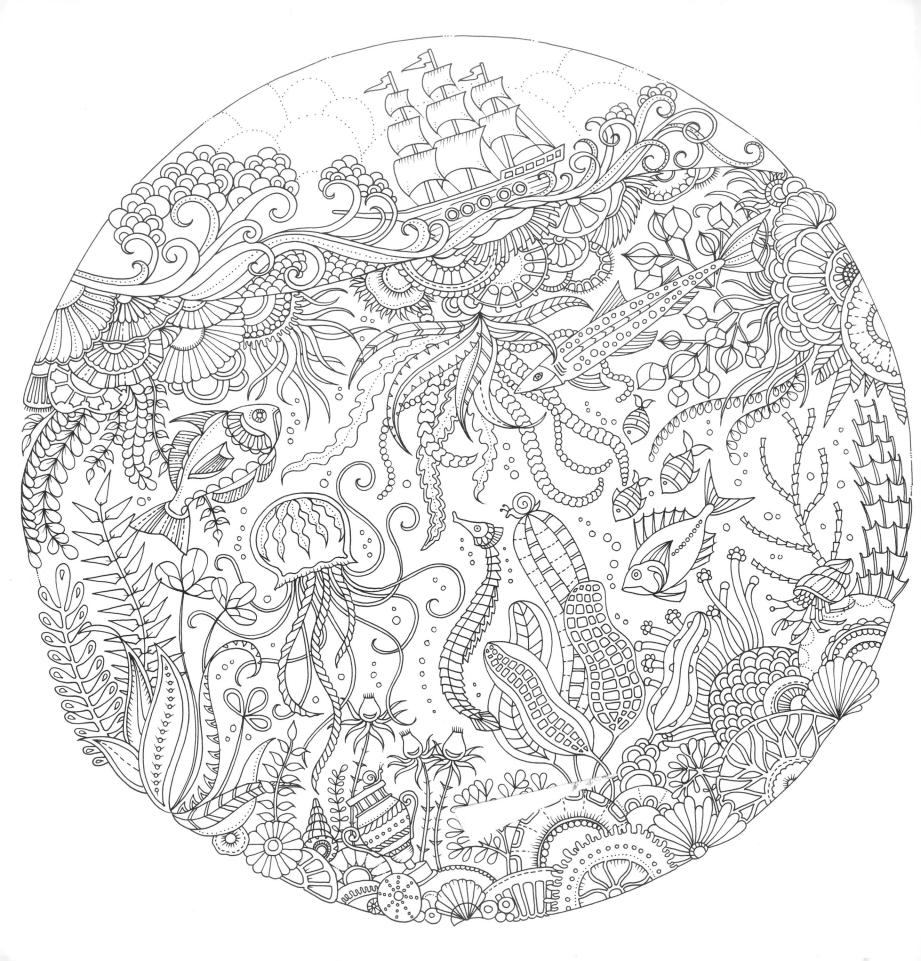

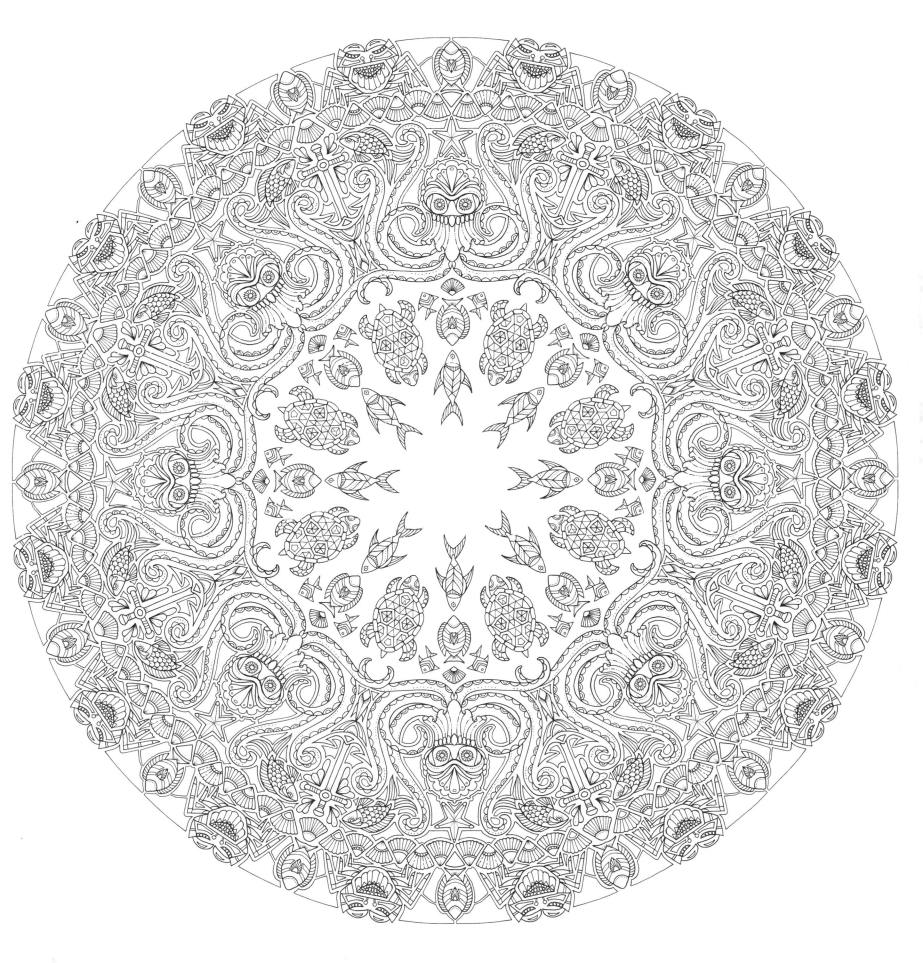

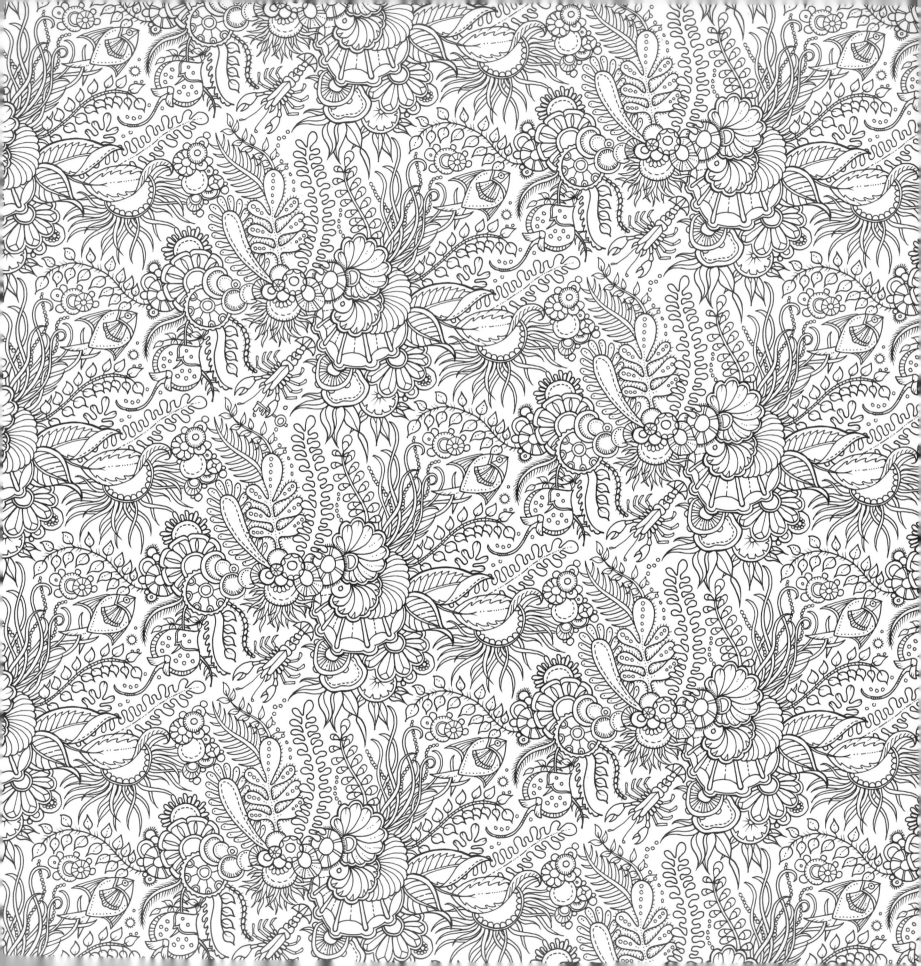

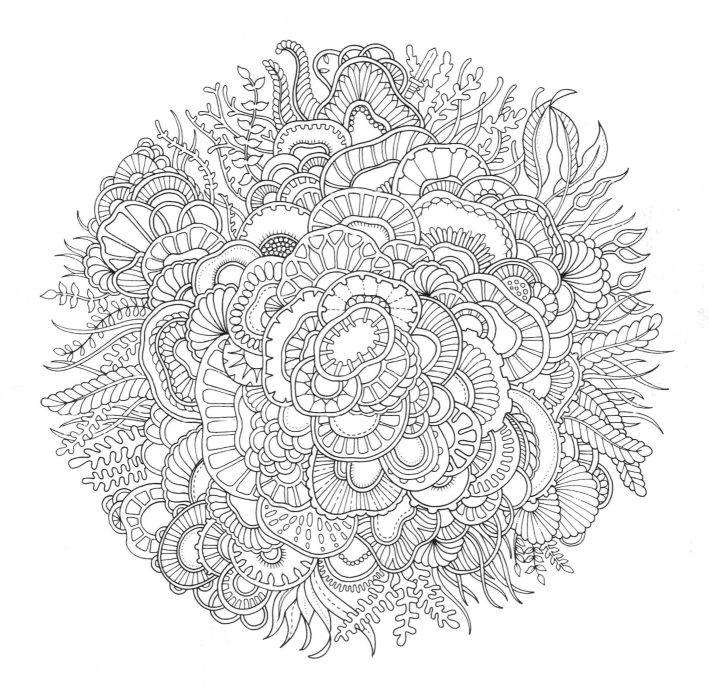

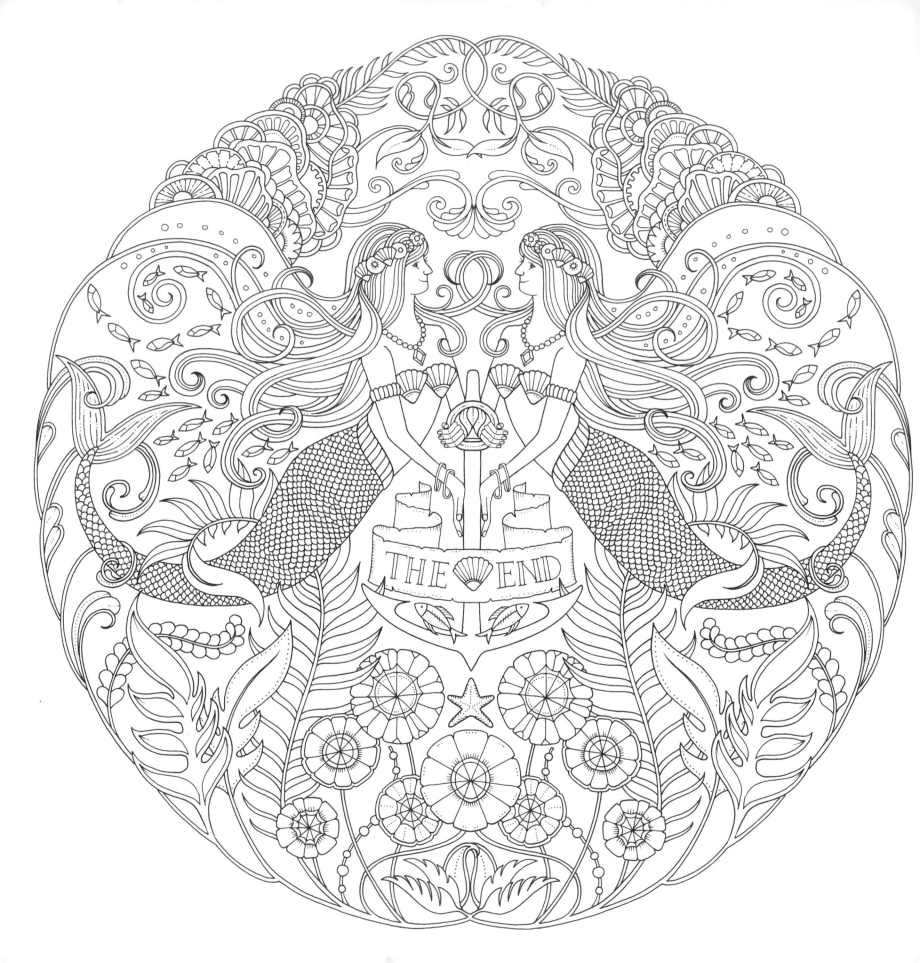

Key to the Lost Ocean . . .

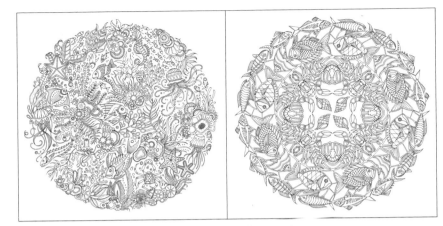

1 goblet, 1 crown 4 diamonds

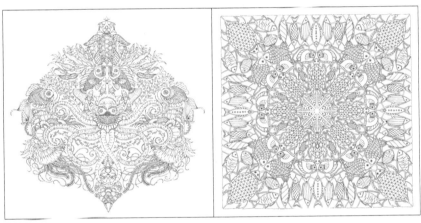

1 key 1 diamond

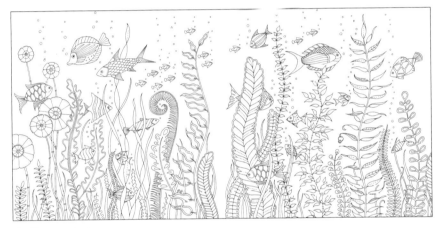

1 diamond ring

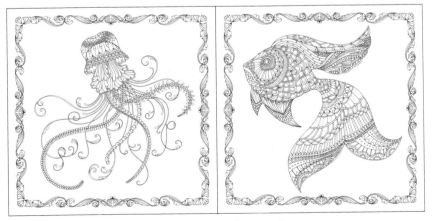

4 diamonds 4 diamonds

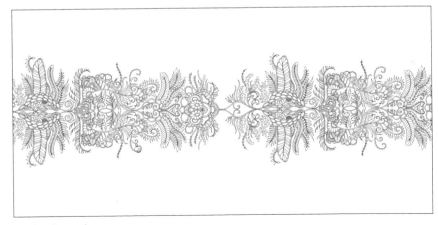

1 magic potion

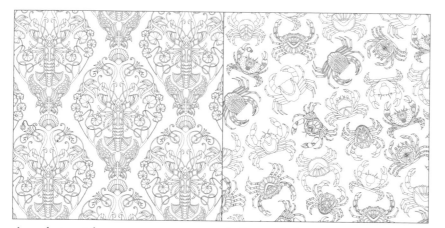

1 pocket watch 1 diamond ring

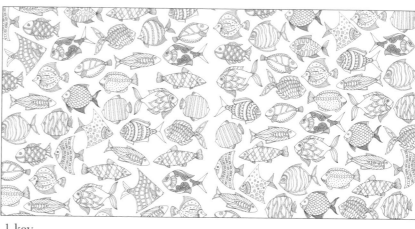

1 key

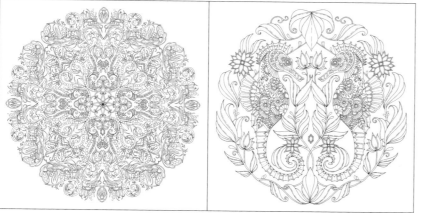

1 diamond 1 diamond

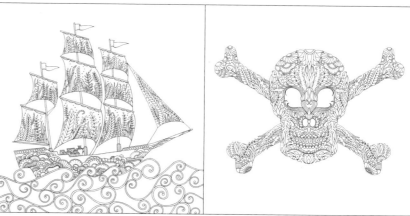

1 vase 1 dagger

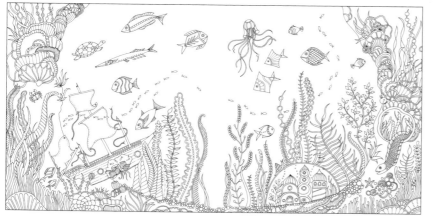

1 magic potion

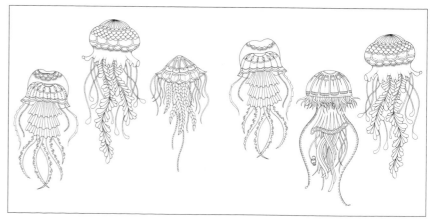

1 diamond ring

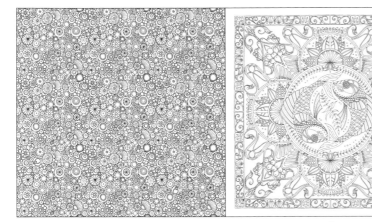

2 diamond rings

1 diamond ring

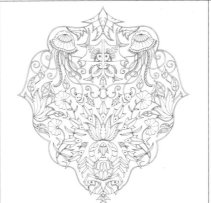

2 magic potions

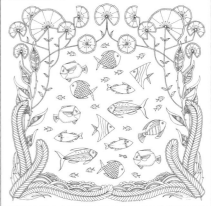

1 key

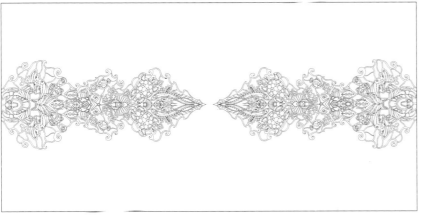

1 diamond

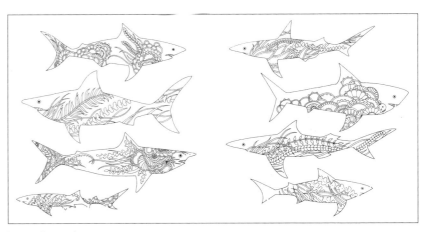

1 magic potion

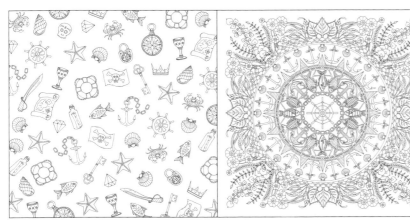

4 goblets, 4 diamonds, 3 keys,
3 crowns, 3 anchors, 3 messages
in bottles

20 anchors, 8 diamonds

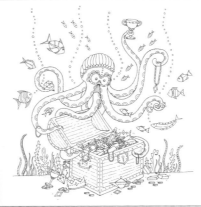

2 goblets, 2 crowns, 8 diamonds,
1 pocket watch, 1 magic lamp,
1 message in a bottle, 1 key, 6 pearl
necklaces, 7 gold bars, 39 gold coins

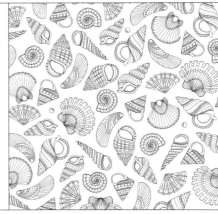

3 pearls

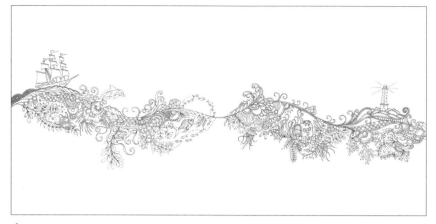

1 crown

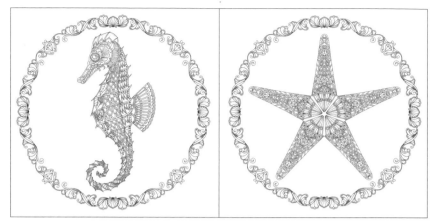

4 diamonds

4 diamonds

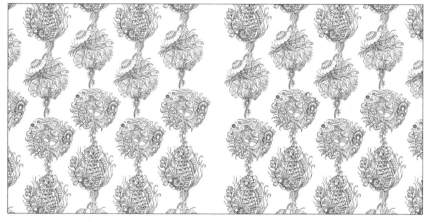

1 pocket watch

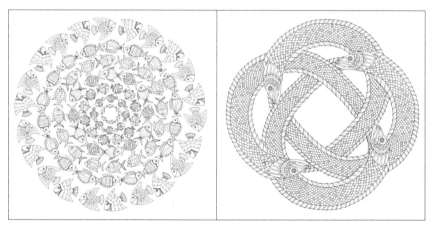

1 diamond ring

1 diamond ring

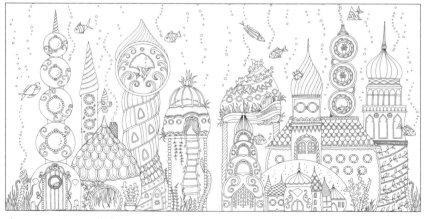

1 crown, 1 magic lamp

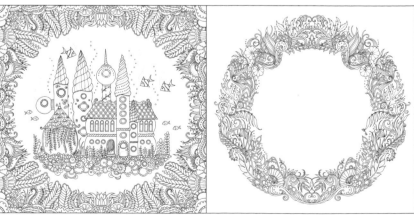

1 crown, 1 pearl necklace

1 key

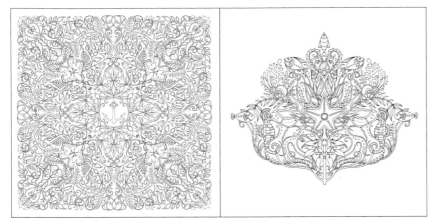

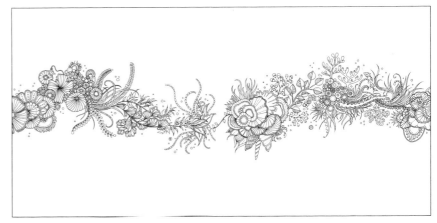

1 anchor, 1 key

1 dagger, 1 anchor

1 pocket watch

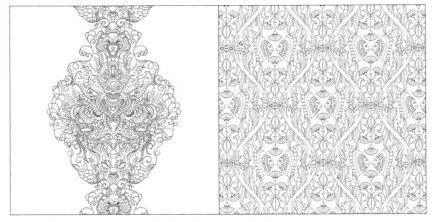

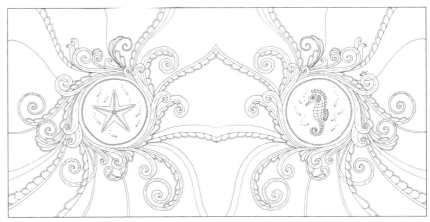

1 diamond ring

2 diamond rings

1 magic lamp

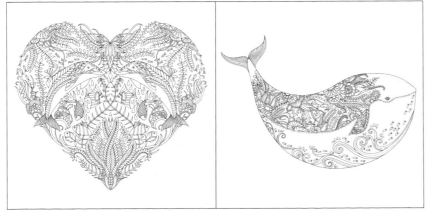

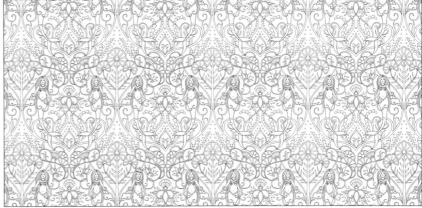

1 goblet

1 diamond

1 crown

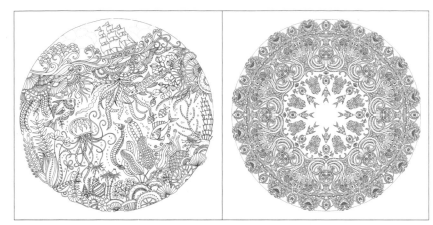

1 vase

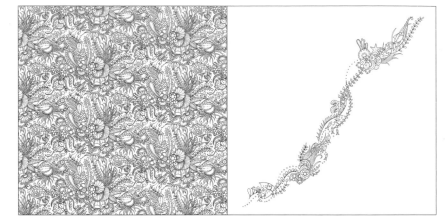

8 anchors

1 key

3 diamonds

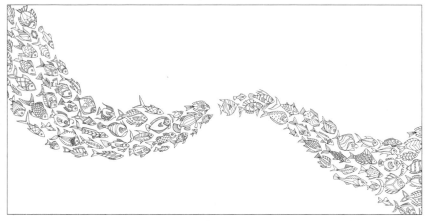

1 diamond

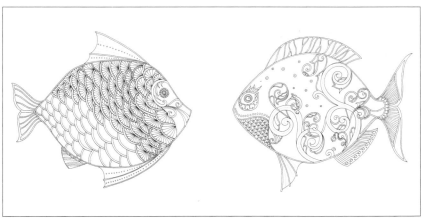

1 pocket watch

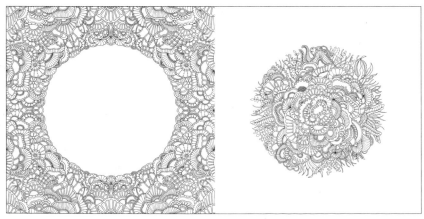

1 dagger

1 anchor, 2 pearl necklaces